Advisory Group
Michael Diamond
Marilyn Kohn
Karen Kornblum
Jaime Levine
David Neuwirth

Liaisons

Katherine Bar-Tur, LCSW
NASW, NY Center for Divorce & Family Mediation

Chris Christian, PhD
Division 39

Coline Covington, PhD
International Dialogue Initiative

Anna Fishzon, PhD
Das Unbehagen

Ken Fuchsman, EdD
International Psychohistory Association

William W. Harris, PhD
Children's Research and Education Institute

Leon Hoffman, MD
New York Psychoanalytic Society and Institute

Paul D. Kreisinger, LCSW
New Jersey Society for Clinical Social Work,
American Association for Clinical Social Work

David Lotto, PhD
Western Massachusetts and Albany Area Association
for Psychoanalytic Psychology

Kerry Malawista, PhD
New Directions, Contemporary Freudian Society

Becky McGuire, PhD
Seattle Psychoanalytic Society and Institute

Arnold Richards, MD
American Institute of Psychoanalysis,
New York Psychoanalytic Society and Institute

Dana Sinopoli, PhD
Philadelphia Society for Psychoanalytic Psychology,
Division 39

Contributors

Sheldon Bach, PhD, is an adjunct clinical professor of psychology at the New York University postdoctoral program for psychoanalysis, a training and supervising analyst at the Contemporary Freudian Society and the Institute for Psychoanalytic Training and Research, and a fellow of the International Psychoanalytical Association. He is the author of several books on psychoanalysis and of many papers, some of which have been collected in *Chimeras and Other Writings: Selected Papers of Sheldon Bach* (IPBooks, 2016). He is in private practice and teaches in New York City.

Chris Bell, PhD, is a visiting assistant professor of psychology at Saint Anselm College. His research considers personal experiences of change in psychoanalysis/psychodynamic psychotherapy and cognitive-behavioral therapy. His most recent publication is a chapter titled "Critical Perspectives on Personality and Subjectivity" in *A Critical Introduction to Psychology* (Nova Science Publishing, 2019).

Daniel Benveniste, PhD, is a clinical psychologist in the Seattle area in Washington State and a visiting professor of clinical psychology at the Wuhan Mental Health Center, in the People's Republic of China. He is the author of *The Interwoven Lives of Sigmund, Anna, and W. Ernest Freud: Three Generations of Psychoanalysis* (IPBooks, 2015) and is an honorary member of the American Psychoanalytic Association. Website: benveniste phd.com

Ofra Bloch, PhD, is a documentary filmmaker, psychoanalyst, and supervisor in private practice in New York City. Her interests focus on psychoanalysis and social action, transgenerational trauma, and the immigrant experience.

Kate Daniels, is the Edwin Mims Professor of English and director of creative writing at Vanderbilt University. She is the author of six collections of poetry, including *In the Months of My Son's Recovery* (May 2019). A graduate of the New Directions program at the Baltimore Washington Center for Psychoanalysis, she has been a member of the writing faculty there for a decade. She lives in Nashville. Website: katedanielspoetryandprose.com

Michael Diamond, PhD, is professor emeritus of public affairs and organization studies at the University of Missouri, Columbia. Since 2016, he has been a resident of New York City and an organizational consultant, political theorist, and political psychologist. He is the author of *Discovering Organizational Identity* (2017) as well as the author/coauthor of other books and scholarly articles and is currently a faculty and steering committee member of the Gould Center for Psychoanalytic Organizational Study and Consultation at IPTAR, where he is an honorary member. In 2019, Michael received the award of Distinguished Member of the International Society for the Psychoanalytic Study of Organizations (ISPSO). He is a previous recipient of the Levinson Award for Excellence in Consulting from the American Psychological Association.

Iris Fodor, PhD, is Professor Emerita in the Department of Applied Psychology at New York University and is the former director of the NYU School Psychology doctoral programs. She is a clinical psychologist and Gestalt therapist in New York City known for teaching and writing about feminist therapy, anxiety management, mindfulness, and integrative therapy. Iris is also a social activist and photographer who has collaborated on digital storytelling projects with Tibetan adolescents in India, and adolescents in South Africa and Peru. Recent work focuses on memoir and experiential writing.

Daniel José Gaztambide, PsyD, is a visiting assistant professor at the New School for Social Research, a clinical psychologist in private practice, and an analytic candidate at the New York University Postdoctoral Program in Psychotherapy and Psychoanalysis. He is the author of the book *A People's History of Psychoanalysis: From Freud to Liberation Psychology* (Lexington Books, 2019). He was also featured in the documentary *Psychoanalysis in el Barrio* (Winograd & Christian, 2015).

William W. Harris, PhD, is a child advocate who works with policy makers on efforts to increase the government's investment in low-income young children and families. He is chairman of Children's Research and Education Institute and an adjunct professor at UCSF Medical School, in the Department of Psychiatry.

Michael McAndrew, MA, LPCC, is a Lacanian psychoanalyst in formation from Denver, Colorado. He is a poet and a veteran of the United States Navy. Michael is a member of the Denver Veterans Writing Workshop, where he writes primarily about war neuroses and psychoanalysis. Michael is also a member of the Colorado Analytic Forum of the Lacanian Field, as well as a member of the School of Psychoanalysis of the Forums of the Lacanian Field (IF-SPFLF).

Elizabeth Herman McKamy, MSW, presents and consults nationally about retirement, particularly as it impacts careers characterized by long-term mutual engagement with clients. Recent publications include "Closed for business: Reflections on a psychoanalytic psychotherapist's voluntary retirement" published in *Contemporary Psychoanalysis* (2015), and "Retirement from psychotherapy practice: A mutually generative rite of passage," published in *Moments of Meeting in Psychoanalysis* edited by Susan Lord, PhD (Routledge, 2018). "For Crying Out Loud" is McKamy's first published piece of fiction.

Zak Mucha, LCSW, is a psychotherapist in private practice and an analytic candidate at the Chicago Center for Psychoanalysis. He spent seven years working as the supervisor of an assertive community treatment (ACT) program, providing 24/7 services to persons suffering from severe psychosis, substance abuse issues, and homelessness. He is the author of *Emotional Abuse: Manual for self-defense* and the recent poetry collection *Shadow Box*.

Daniel Rosengart, PsyD, teaches at John Jay College of Criminal Justice and maintains a private practice in New York City. He won the JAPA New Author Prize and is an editor of an upcoming translation and commentary of Alfred Lorenzer's "In-Depth Hermeneutical Cultural Analysis." He writes about psychoanalysis, race, and theology.

Jared Russell, PhD, is an analyst in private practice with offices in New York City and Wilton, Connecticut. He is a member of IPTAR and NPAP. He is the author of *Nietzsche and the Clinic: Psychoanalysis, Philosophy, Metaphysics* (Routledge, 2017) and *Psychoanalysis and Deconstruction: Freud's Psychic Apparatus* (Routledge, 2019).

Gary Senecal, PhD, is an assistant professor of human services and rehabilitation studies at Assumption College in Worcester, Massachusetts. His research is on the social psychology of violence and with a specialized focus on contact sport athletes and military veterans. He is a member of the Army Reserve.

Aneta Stojnić, PhD, is a candidate at IPTAR (adult psychoanalysis and CAP Programs) and a theoretician, curator, artist, and professor of performance and media theory. She has published three books and numerous essays and academic papers. Her latest book is *Shifting Corporealities in Contemporary Performance: Danger, Im/mobility and Politics* (Palgrave Macmillan, 2018).

Juan Pablo Valdivieso Blanco, is a Venezuelan visual communicator, who graduated from Prodiseño (2002) and received a Bachelor of Philosophy from the Catholic University Andrés Bello (2019). He is currently pursuing postgraduate studies at Simón Bolívar University. His visual inquiries began during design career and continue in later years, as a broadcasting designer in motion graphics for Sony Entertainment Television. In 2009, due to a desire to reunite with his body and, simultaneously, with a spiritual life, he decided to make a professional move away from design to devote himself to yoga. He is currently a yoga teacher.

Hattie Myers, PhD, is a training and supervising analyst at the Institute for Psychoanalytic Training and Research (IPTAR). She is co-editor of the books *Terrorism and the Psychoanalytic Space* (Pace University, 2003) and *Warmed by the Fires; the Collected Papers of Allan Frosch* (IPBooks 2019). Her nonfiction and poetry will appear in the forthcoming book *Dante and the Other* (Routledge, 2021). Email: Hmyers@analytic-room.com

Mafe Izaguirre is a New York–based Venezuelan artist, graphic designer, and educator. She leads the strategic design advisory firm, Simple 7 Lab, specializing in brand management. Website: simple7lab.com Email: mafe@simple7lab.com

Eduardo López is a Chilean graphic designer and educator with more than thirty-five years of professional experience in the editorial design field.

Index

Hattie Myers
hatbmyers@gmail.com

TREMORS

"To be *stupefied*," Jared Russell explains in his provocative essay "Stupidity," "is to regress in the face of the unexpected, to have one's critical faculties paralyzed." The contributors to ROOM 2.20 may be terrified and even heartbroken in the face of the unexpected, but they are not stupefied. They have some very clear ideas that we need to hear. They are telling us that we are living on a fault of our own making that is bigger than the San Andreas, and we are feeling the tremors. Each of these authors are telling us how, when facts and reason hold no sway, when fear, anger, and yes, even love render us numb or blind, we are failing spectacularly and tragically to live up to our humanity.

Iris Foder writes in "After the War" that she really believed the violence would stop, the poverty would end, and the celebrations would begin in the Bronx. Michael McAndrews recalls in "War and Grief" his experience aboard a nuclear-powered aircraft carrier the day after Trump assassinated Soleimani, during a different "tense state of belligerence" with Iran. "I surely wasn't the only sailor in the American or Iranian Navy who was relieved when the crisis was averted. I feel," he writes, echoing Foder from a distance of three generations, "both too old, at thirty-four, and not old enough to see history repeat itself."

"And Then It Was Over" completes William Harris's homage to Marshal McLuhan's prophetic vision of how media would come to infiltrate our souls and stop time. Beginning with "Twitter Dee Twitter Dum" (ROOM 6.18) and progressing to "Still Here" (ROOM 10.19), Harris's triptych has taken us from an initial jumble of horror to the tense marking of days, to now "living in an earthquake…awaiting the aftershocks we know will come."

Daniel Benveniste lived through the political earthquake that destroyed Venezuela and has seen the violence, prejudice, and hatred that authoritarian bullies like Chavez and Trump incite. He has witnessed the consequences of their Faustian bargains: "There are enemies out there; stay close to me and I will protect you." In "Diving into the Stream," Benveniste describes what it was like to be swimming in a sea of "political countertransference." "Sometimes in the presence of political tyranny, which threatens the very conditions of the analytic process, one must take a stand. How can a patient free-associate," he writes, "if there is no free speech? How can a person think freely if there are forbidden topics?"

Arnold Richard's entire life has been infused by an indomitable "Spirit of Activism." In this poignant interview, he tells Room's editor Aneta Stojnić, "I think all psychoanalysts perhaps have a special obligation to become activists for causes that affect the lives of their patients. There is no way of treating a person separate from the fact that they can't have health care or if they are in an environment that is going to kill them. So you can't really isolate what you do in the office from what you do in the world."

Coming from a different direction, Daniel José Gaztambide found he couldn't isolate the world from psychoanalysis. Liberation Psychology is the story of how, as a child growing up in Puerto Rico, he came to write *The People's History of Psychoanalysis*.

"The most basic concept of psychoanalysis is that our sources of motivation are unconscious and therefore hidden from us," writes Ofra Bloch, a New York psychoanalyst and filmmaker. Consciously, Bloch, who was born in Israel in the aftermath of World War II, knew only that she wanted to interview children of former Nazis and neo-Nazis in order to stop her own cycle of hate and othering, but the project compelled her to also interview Palestinians

whose homes were stolen and whose family members were murdered.

In "Afterward," Bloch brings to the screen the strength that was required to hear and connect to these "others" amidst her own rage and guilt and sadness. "I was unaware," Bloch writes, "that I was making a film about myself and my own journey of discovery and change." She was undoubtedly also unaware of the impact that her personal journey would have on her film's viewers. In her essay and film, we witness the powerful potential of analytic space to contain the untenable.

Michael Diamond and Sheldon Bach use their psychoanalytic understanding to examine the collapse of our democratic space. In "Trump's Wall," Bach suggests that the rapid technological and societal changes over the last decades have left many people feeling unmoored and alone. Our president's "frantic attempt to replace loosening internal structure with a dictatorial external structure" has a cultish appeal to a populace in a state of disorientation and sudden loss. In "The Fissure," organizational theorist Michael Diamond writes that the bipartisan split, fueled by projection and disinformation, has resulted in a deadly fissure that threatens the collapse of our democracy. Diamond believes we must continue to "neutralize" this violent state of affairs through the testimonies of nonpartisan civil servants and through overpowering the lies and projections with "reality-based counter-messaging."

Taking a different slant on societal destabilization and political polarization,

Chris Bell and Gary Senecal's essay "Projective Identification: Unconscious Defense or Conscious Offense" directs our focus to an insidious psychoanalytic phenomenon. By insinuating that his opponents operate using malevolent tactics at his own primitive moral level, Trump's projections create a "false equivalency, rather than enabling clear symbolic distinctions to be made." "Projections have a psychological impact upon their recipient or target, leading them, if only momentarily, to identify with the projections. Thus, not only can public perception be subtly altered and destabilized by psychological projections, but also the recipients/targets of projections can themselves become ensnared in unwanted identifications precipitated by the projections." Don't be fooled, Bell and Senecal warn us. This is no unconscious accident of mental instability. This is a powerful weaponized strategy meant to destroy and conquer.

But as Daniel Rosengart adds in his essay "Reading Racism Deeply," there are also unconscious libidinal forces at play equally capable of devouring and destroying. "If we read racist

discourses as having no more potential than as hiding places for hate, we impoverish the racist's unconscious and forget the fact that a symptom is fundamentally an act of creativity in a mad world." It is an extraordinary analytic feat for Rosengart to imagine fascism or racism or sexism as "an act of creativity" even in a "mad" world. But, Zak Mucha writes in "Reassembling Fragments," a poetic/psychoanalytic act of creativity in and of itself, "Analytic work demands we incorporate the uncertainty of the world, the unknowable, into our existence. The horrific *what if*s, *what next*s, *and should*s and the dread of *how do they see me exist*, marking the unbearable anxieties left wordlessly outside of our narratives while driving our behavior." Let's just say there are certain narratives that do try our souls. It isn't easy.

For three years now, the authors and artists who have contributed to the creation of ROOM have been telling us that we are living on the edge of crisis. The historian Walter Benjamin believed, based on an understanding of the oppressed, that all of history might be defined as a perpetual state of emergency. Psychoanalysis understands this well; psychoanalysis recognizes that the present is inextricable from the past, from that which has been oppressed and repressed and all that has come before. We know that consciousness is a state of perpetual emergence. Russell's essay echoes what Benjamin wrote: "Thinking can suddenly halt in a constellation overflowing with tension." The writers, artists, filmmaker, and psychoanalysts who have contributed to ROOM 2.20 are thinking hard. The tremors beneath our feet are increasing— and we are paying attention. ▪

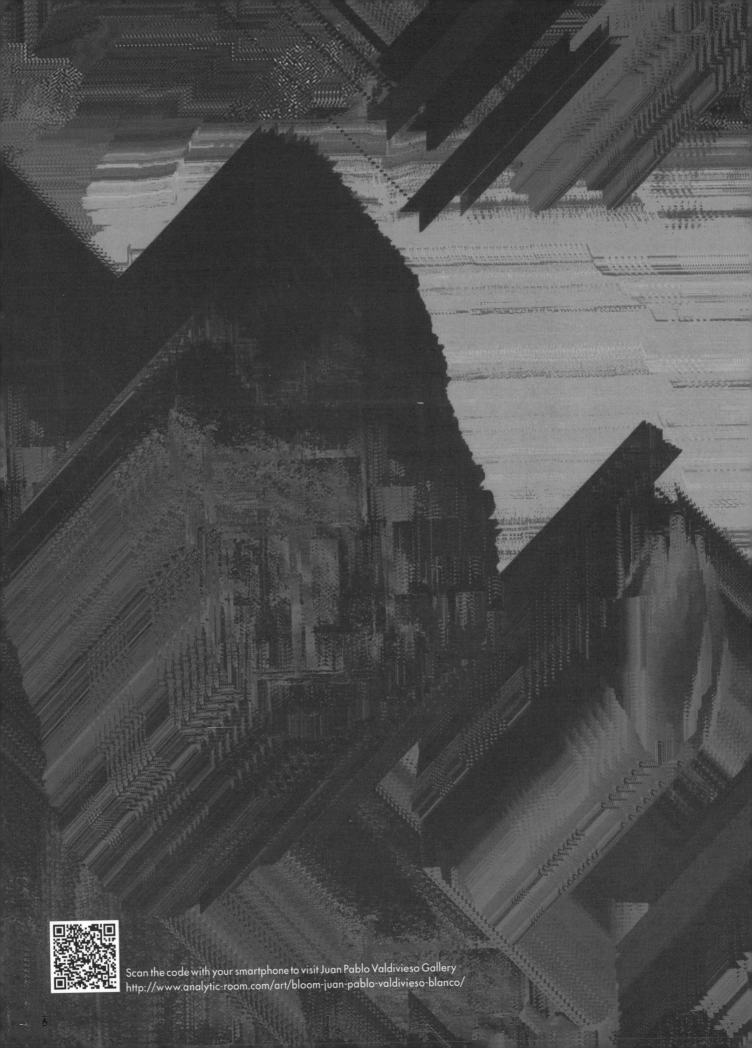

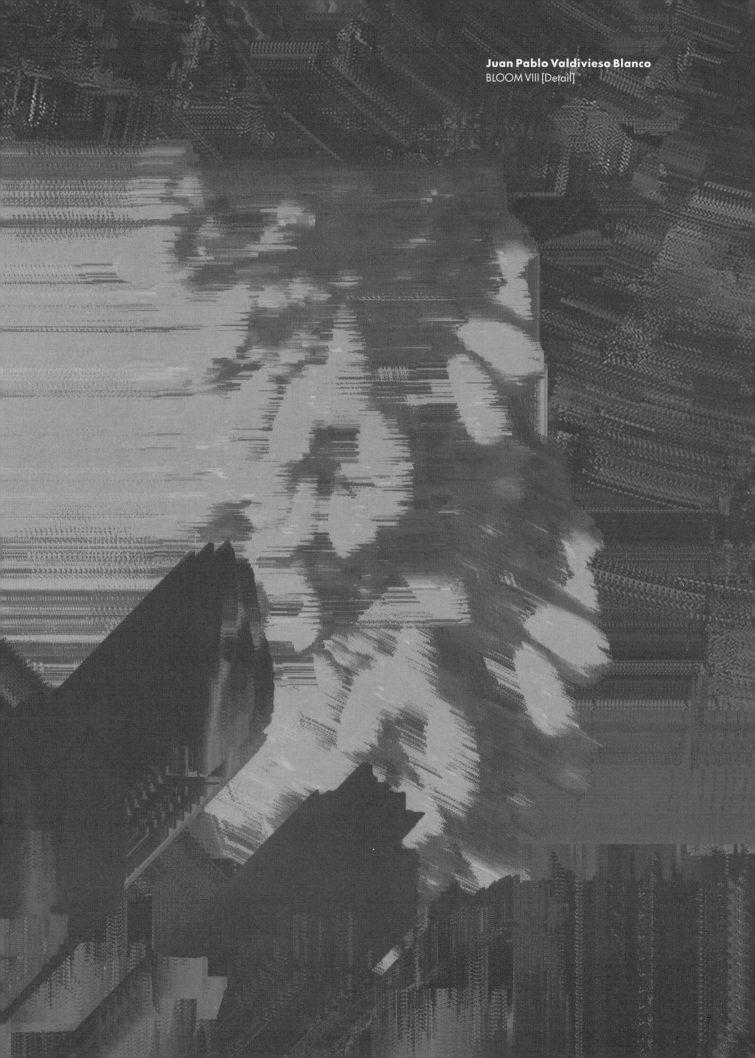

Juan Pablo Valdivieso Blanco
BLOOM VIII [Detail]

DIVING INTO THE STREAM

Daniel S. Benveniste
daniel.benveniste@gmail.com

Part I
Standing up- to Authoritarianism:
Chávez and Trump

I relocated from San Francisco to Caracas, Venezuela
in March 1999, just one month after Hugo Chávez assumed
the presidency. He presented himself as a socialist intent
on helping the underclasses and ending corruption,
and I was ready to sign up. In addition to my practice
and teaching at Universidad Central de Venezuela
and Universidad Católica Ándres Bello, I started writing
a monthly article in the English-language newspaper under
the title "The Psychology of Everyday Life," addressing
topics such as childrearing and adolescent issues. Shortly
after my arrival, it became clear to me that Chávez had
nothing to do with socialism and his regime was even more
corrupt than the previous Venezuelan governments. There were
many massive demonstrations against the government,
and on April 11, 2002, the entire freeway was blocked
with a peaceful demonstration of 800,000 people. Chávez met
the demonstrators with guns and tanks. Nineteen people
were killed and a hundred injured before it came to a bloody
end. As a foreigner, I didn't see it as my place to take
a stand politically but my next article for the newspaper
was on "The Authoritarian Personality."

As Chávez's authoritarian regime dug in, I wrote other arti-
cles, such as "Effective Communication: The Real Power
of the People"; "Conflict Resolution from the Kitchen Table
to the Negotiation Table"; "The Individual and Culture,
Violence, and the Word"; "Collective Hysteria and Fear:
How to Keep Critical Situations in Perspective";
and "Civilization and Its Discontents Revisited:
What Freud Might Say about Venezuela Today."
During the eleven and a half years that I lived in Venezuela,
I watched the country gradually and then more rapidly being
destroyed. As a foreigner, I initially remained silent about
this disaster. But then, on December 6, 2002, I watched,
live on TV, as seventeen-year-old Keyla Guerra died
from a gunshot wound to the head in a plaza
not far from my home. Keyla was peacefully demonstrating
against the Chavista regime. She and two others—
Jaime Giraud Rodriguez (58) and Josefina Lachman
de Inciarte (76)—were killed that night by a Chavista gunman,
and many more were injured. (You can see a short video
of that night and witness what I saw live on TV. The injured
are pictured at 1 minute 52 seconds.)

The murdered that night were three of hundreds who would
eventually be killed and thousands who would be injured,
jailed, and tortured in the coming years. Watching Keyla
Guerra die on TV, I knew I could no longer be a bystander.
I began making contacts with opposition leaders,

Link
http://prohibidoolvidarlo.blogspot.com/2010/02/
los-3-asesinatos-de-plaza-altamira.html

writing articles, and trying to offer psychologically informed perspectives on strategy aimed at finding a democratic resolution to the problems of the country. I wrote dozens of articles and met with members of Venezuela's civil society, and yet, I was spectacularly unsuccessful in my efforts. When we observed the rising tide of street violence and anti-Semitism in Venezuela, my wife and I decided it was time to get out. We returned to the United States in September 2010. I continued my political writing, circulating it on various Venezuelan websites and also trying to discuss my concerns with US politicians. However, these politicians were shockingly unavailable or unresponsive. Finally, I wrote a book about my concerns—*The Venezuelan Revolution: A Critique from the Left* (2015).

My interest and articles on behalf of Venezuela continued until Donald Trump came onto the scene here at home. Observing his actions and hearing his words was like déjà vu all over again. During the Clinton-Trump election cycle, I wrote three articles before the campaign and an open letter to the Republican leaders after Trump was elected. The main message was that I had witnessed firsthand the destruction that Chávez, the so-called socialist, had done in Venezuela, and I recognized how the world was poised to watch a repeat of that destruction in the United States at the hands of a so-called Republican.

Chávez (who died in 2013) and Trump are two of a kind—both bullies, demagogues, and authoritarians with dictatorial ambitions. They speak in violent metaphors and incite violence, prejudice, and hatred. They prop themselves up as strong men, telling the people, "There are enemies out there that threaten you, but if you stay close to me, I will protect you." They are both crude in their language, disrespectful of women, and hostile toward differences of opinion. They are showy, entertaining, and lie with the greatest of ease. They have eroded the institutions of government and the separation of powers and unleashed corruption in broad daylight. They appeal to the lowest instincts of human nature: vengeance, resentment, greed, tribalism, fear, hatred, and intolerance. If we ask, "Do we agree with the Supreme Court justice pick or with the tax reform bill?" we have one kind of discussion, but if we ask what the personality constellation and political plan look like, we are immediately reminded of the worst authoritarian regimes throughout history. The White House doesn't understand why part of the public is so outraged by Donald Trump. They do not understand that Trump looks more like Hugo Chávez and other dictators than any other president in US history. And if our study of world history has taught us anything, we also know we need to act quickly in order to stop such authoritarian trends, which are obvious not just in Trump but also in the 30 percent of US citizens

who support him. Chávez, too, had 30 percent support—even when people were dying of hunger, violence was in the streets, and there was a lack of sufficient medicine.

When I would give parenting or child development lectures in Caracas, parents would always use part of the question-and-answer period to ask my professional opinion about Chávez's psychological diagnosis. I always saw any possible diagnostic label I could assign as completely irrelevant. Diagnoses in their technical sense, including their limitations, are not generally understood by the public. In time, diagnostic terms in public discourse transform into name-calling and disqualifying—idiot, moron, imbecile, schizophrenic, borderline, retard, autistic, and others. The terms *idiot, moron, and imbecile* are no longer even used as diagnostic categories, and the others should never be used as insults. There should never be anything disqualifying about a diagnosis. And, lest we forget, not only Trump but all of our favorite politicians could also be diagnosed. What strikes me as far more important politically is to describe the politician behaviorally, that is, in the terms that are also used to arrive at a diagnosis: he lies, bullies, covers feelings of inadequacy with bravado, distorts reality, projects his own limitations onto others, steals without guilt, is impulsive and self-centered, and so on. This sort of description stirs the passions of the people and allows them to recognize the same features in historical figures, such as in this case other authoritarian rulers.

Psychiatric diagnoses distract us from the political acts of these authoritarian leaders. To say someone is a malignant narcissist reduces the critique into psychiatric jargon when we are better off staying with words like *liar, self-centered, hateful, corrupt, thieving, unethical,* and so on. That said, I applaud the work of Brandy X. Lee, Robert J. Lifton, and the other coauthors of *The Dangerous Case of Donald Trump* (2017), as it is an important book that has highlighted the concerns of many professionals and given the public something more to consider.

I had never been open about my politics with patients until Chávez came into power and I was asked directly by a patient, a military man who worked at the US embassy. He wanted to know and needed to know. Sometimes, in the presence of political tyranny, which threatens the very conditions of the analytic process, one must take a stand. How can a patient free-associate if there is no free speech? How can a person think freely if there are forbidden topics? My clinical mentor, Nathan Adler, was a very active communist in the late 1920s and early '30s, but with the anticommunist atmosphere in the United States, he went underground into social work and then into psychoanalysis. He explained that because of the Red Scare, he never kept process notes. He didn't want to have anything that the government

could steal. One way or another, I think it is worthwhile to investigate our individual reactions to political tyranny and consider the implications they may have for our clinical work—that is, our political countertransference.

How does the nightmare of the Trump era affect me personally? What does my psyche have to do with it? I think we can all find ways in which political dynamics attach to our personal dynamics. I once saw a couple in Caracas with a typical set of marital communication problems, which they explained to me in great detail. At one point I asked them:

"Do you discuss these problems together?"

"Never."

"So, you don't talk much?"

"No, we talk all the time. In the morning, during the day on the phone, and every night."

"So, if you don't talk about your problems, what do you talk about?"

"Chávez!" they said in unison.

"And tell me, Señora, what troubles you most about Chávez?"

"All the insecurity in the country. I just don't feel safe anymore."

"And for you, Señor, what troubles you the most?"

"All the restrictions tying down the owners of small businesses."

Now, both of these concerns were more than accurate concerns about the Chávez regime, but the reader will not be surprised to learn that the wife's biggest complaint about her husband was that she did not feel safe in her marriage, and correspondingly, the husband felt unnecessarily restricted by his wife. This does not invalidate their respective political views nor their held resentments toward one another. It just goes to show that our politics are shaped by our psychodynamics. Some will say the political activity of the analyst compromises abstinence and neutrality and introduces reality factors into the transference. I agree, but all of that can be analyzed.

While no one would deny a psychoanalyst having a private political opinion, some might be concerned about the analyst's public political activity if it occurs in view of the patient or enters the consulting room. We rarely, if ever, discuss our own politics with our patients in terms of their position vis-à-vis our position, but the patient's political views are always up for discussion as derivative material of their psychological dynamics and history, just as religion and philosophy are. The confusion between the analyst's political opinion, political activity, and clinical technique may create problems, which can certainly be analyzed, but they may also support a rationale for the analyst to avoid political engagement.

It is not surprising that when I analyze my emotional reactions to Chávez and Trump, I find a history of old traumas from childhood into adulthood, but I find it curious that many of my reactions have been similar to the emotional reactions of others: terror, disbelief, and perhaps more than anything else, a sense of powerlessness. It then occurs to me that what is activated by authoritarian leaders is the powerlessness of the infant in the face of infantile injustices—the pains of the body and being controlled by and at the mercy of parents. So, what do we do with that? We feel it, we remember, and then we recognize that although we once were powerless, we are no longer. We have education and experience, can join forces with others, and can push back.

You'll recall my saying that after seeing Keyla Guerra dying on TV from a Chavista gunshot to the head, I resolved that I could no longer be a bystander and entered *la lucha* (the struggle) for the liberation of Venezuela. Now, I believe we in the United States are in a similar time of troubles that require all of us to stand up, meet the challenge, and join the struggle. ▪

The three commandments we learn from the Holocaust:

Thou shalt not be a victim,

Thou shalt not be a perpetrator, but, above all,

Thou shalt not be a bystander.

—Yehuda Bauer

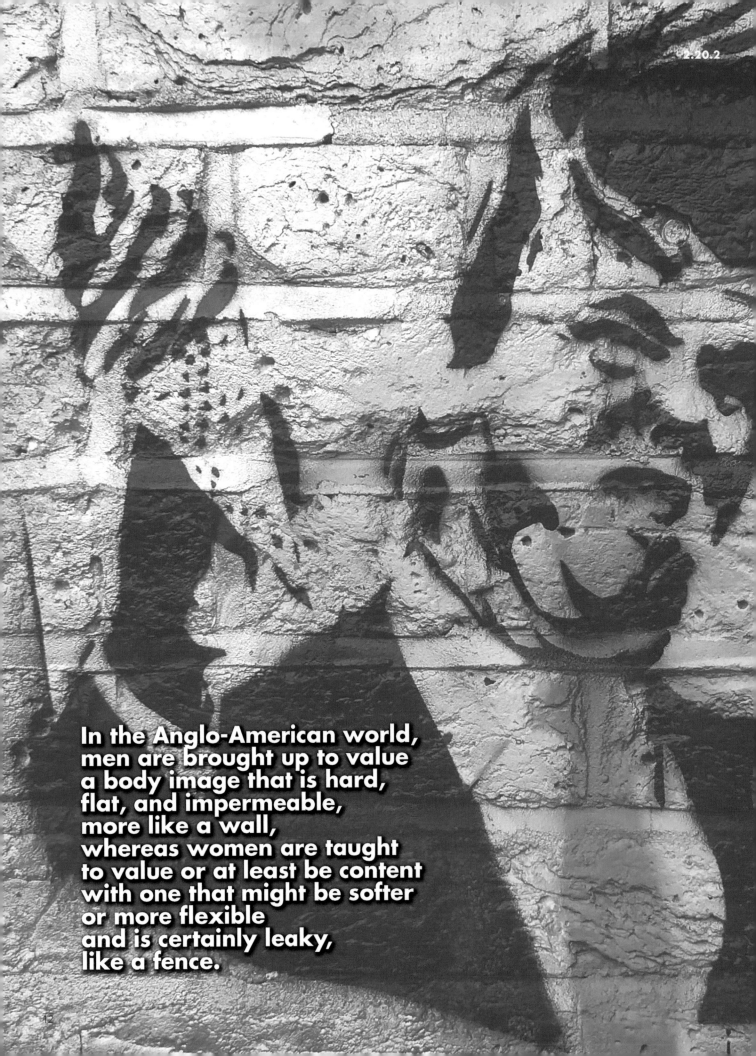

In the Anglo-American world,
men are brought up to value
a body image that is hard,
flat, and impermeable,
more like a wall,
whereas women are taught
to value or at least be content
with one that might be softer
or more flexible
and is certainly leaky,
like a fence.

TRUMP'S WALL

Sheldon Bach
sheldonbach@gmail.com

People might agree that changes in our culture in the past several decades have far exceeded past changes both in their intensity and in the speed with which they have occurred. For example, it was not that long ago in the Anglo-American world when someone might have been, and many were, sent to prison or otherwise persecuted for homosexuality. But just a few painful decades later, homosexual sex and relationships generally became legal in the United States. Now it has also become feasible, both medically and legally, to actually change one's birth sex.

The growth of the internet and other technology has brought undreamed-of changes, so that even a disempowered inhabitant of the poorest country in the world can now conceivably share his thoughts with others all over the globe.

The evolution of the brain to coordinate with the changing environment seemed designed to occur over millennia, not overnight, and these enormous and rapid changes have left many people in a state of disorientation about who they are, about their situation in life, about their own self-definition, and about where they stand in relation to others. They have lost an orientation, they have lost their borders, and they have lost the barriers that separate one thing from another and leave them knowing at least what they are opposed to, even if they are not certain of what they actually stand for.

Only a few generations ago, one could watch a television serial or read a popular novel and know, with some certainty, what was considered normal or usual for a life lived in a certain environment, even if it was being mocked or vilified by the writer. But today in many circles, it is no longer possible to know what might be thought of as normal; normality has been so changed and deconstructed that some people would rather invent nonexistent aberrations than be taken as normal.

This rather sudden loss of the mental structure and hierarchy that help us denote normalcy has led many people to feel empty and alone. In this world where one can be connected twenty-four hours a day to anyone or anything, unprecedented numbers of people privately report that they feel lonely and are without friends.

It is their own feelings of loneliness, hierarchical loosening, and loss of direction and identity that people are addressing as they seek to buttress this interior softening with an exterior hardness and to replace natural internal order with externally imposed dictatorship. Some people, because of these social changes or actual changes of job or status, feel they are losing or have lost their own identity. They seek to bolster or replace these internal losses with increasing external harshness, division, separation, envy, and revenge.

In the Anglo-American world, men are brought up to value a body image that is hard, flat, and impermeable, more like a wall, whereas women are taught to value or at least be content with one that might be softer or more flexible and is certainly leaky, like a fence. In this culture, when men's internal structures loosen, they begin to experience castration terror, unless they have been emotionally educated. This also applies to many women, although their natural predilections help somewhat in this respect.

Trump's walls are a frantic attempt to replace loosening internal structure with a dictatorial external structure, so that those who have joined his cult will feel their confusing internal disorder replaced by an external order, their loneliness replaced by obedience, and their friendships replaced by shared loyalty. These are some of the internal psychological causes that have led to the astonishing growth of dictatorial populism in this country and elsewhere throughout the world. ▪

Projection as a Political Weapon: From Unconscious Defense to Conscious Offense

Chris Bell
chrisramonbell@gmail.com

Gary Senecal
gsenecal2@gmail.com

Donald Trump's penchant for attacking his opponents by projecting onto them his own disavowed personal attributes and apparent self-assessments has been a consistent feature of his rhetorical style and remarked upon by many observers. For instance, in her recent book *The Death of Truth: Notes on Falsehood in the Age of Trump* (2019), Michiko Kakutani observes, "Trump has the perverse habit of accusing opponents of the very sins he is guilty of himself: 'Lyin' Ted,' 'Crooked Hillary,' 'Crazy Bernie.' He accused Clinton of being 'a bigot who sees people of color only as votes, not as human beings worthy of a better future,' and he has asserted that 'there was tremendous collusion on behalf of the Russians and the Democrats'" (p. 95). In a recent *New York Times* opinion article, Michelle Goldberg referred to Trump as a "Master of Projection" and noted that many instances of Trump's projections were uncannily predictive of his future actions as president, thus properly constituting themselves as projections only in retrospect. Examples include roundly criticizing Mitt Romney for failing to release his tax returns and berating Barack Obama for watching too much TV in the White House, playing too much golf, overusing Air Force One for "politics and play," and potentially leading America into WWIII (Goldberg 2020). Further examples of Trump's projections include accusing Joe Biden of nepotism, referring to Joe Biden as "Plugs Biden" when Trump is so clearly the product of massive cosmetic work, and saying there is no way Nancy Pelosi prays for him, since she only prays for herself. Recently, in an interview with MSNBC, the psychoanalyst and psychiatrist Lance Dodes noted, "[Trump] tells other people that they are what he is. It's a common enough [defense] mechanism in early childhood, but as an adult, using it all the time, it is what we would call primitive." Dr. Dodes contends that Trump's predilection for the defense mechanism of projection is "primitive," since it bypasses engaging with his opponents at the level of logical argumentation, which would involve at a minimum the cultivation of some sort of background knowledge on a topic and engaging in the necessary preparation in order to make a reasoned or rhetorically persuasive case about his favored positions and/or why he is being treated unfairly. While Dodes is right to emphasize that Trump's use of psychological projection may not be a particularly mature defensive style, it is nevertheless surprisingly effective at discrediting his opponents and bringing them down to his level. As such, there is a distinct danger in writing off Trump's projections as simply "primitive," infantile, or unrefined, since in fact they operate as an effective political weapon.

Projection as a Form of Disinformation

In what sense are Trump's projections an effective political weapon? At a fundamental level, psychological projections can function to make the relevant distinctions of a situation illegible or difficult to parse, such that it creates confusion about a situation's basic parameters and thereby serves to obscure its very reality. According to WW Meissner (1988), "The result of these processes [of projection] is a fundamental confusion and an incapacity to differentiate subject and object, reality and fantasy, along with an inability to differentiate the real object from its symbolic representation" (p. 38). Thus, projection constitutes "a form of interpretive distortion of external reality" (p. 32). Projections serve to muddy the waters and give the outward appearance that Trump's opponents are operating with the same tactics, intentions, or even at the same moral level as Trump himself, creating a false equivalency, rather than enabling clear symbolic distinctions to be made. For example, Trump recently referred to Adam Schiff, Chairman of the House Intelligence Committee, as a "deranged human being," who "grew up with a complex for lots of reasons that are obvious," concluding, "I think he's a very sick man, and he lies" (Cole, 2019). While this description appears to be more a reflection of Trump himself than of Schiff, it would be a mistake to disregard its potential social-psychological consequences, the most direct of which is planting a seed of doubt about the probity of Adam Schiff in public consciousness. Furthermore, projection can become a quite insidious form of psychological manipulation in its variant as *projective identification*, where the qualities being projected onto the other interpellate or hail this other in such a way

15

that they unwittingly identify with what has been projected onto them, thus enabling a kind of control over them. Elaborating on this variant of projection, Meissner (1988) states,

> …*projective identification* represents an omnipotent fantasy that unwanted parts of the personality or of the internal objects (acquired by introjection) can be disowned, projected, and contained within the object into which they are projected. In consequence, parts of the ego are thus projected into the object, and *the object is experienced as controlled by the projected parts and imbued with specific qualities related to those parts… The object thus becomes a bizarre object composed of parts of the self and parts of the object in a relationship of container and contained that strips both of any inherent vitality or meaning.* (p. 39, emphasis mine)

Otto Kernberg provides a helpful clinical example of this phenomenon by describing when he felt compelled despite himself to identify with the projections of an analysand. Kernberg (1987) states,

> I realized she had even managed to activate in me, during the last session, whatever ambivalences I myself experienced about the town in which I lived. Only now did I become aware that this town also stood for me in the transference; the town and I also represented her own devalued self-image projected onto me, while she was identifying with the haughty superiority of her mother. (p. 807)

As such, projections can clearly have a psychological impact upon their recipient or target, leading them, if only momentarily, to identify with the projections. Thus, not only can public perception be subtly altered and destabilized by psychological projections, but also the recipients/targets of projections can themselves become ensnared in unwanted identifications precipitated by the projections.

Insofar as projections function to mislead both third party observers as well as their "targets," they qualify as a form of disinformation. In his article "What is disinformation?" Don Fallis (2015) contends that "disinformation is misleading information that has the function of misleading someone" (p. 413). Fallis elaborates,

> Most forms of disinformation, such as lies and propaganda, are misleading because the source intends the information to be misleading. But other forms of disinformation, such as conspiracy theories and fake alarm calls, are misleading simply because the source systematically benefits from their being misleading. Even though they might differ in terms of how that function was acquired, all instances of disinformation are unified by the fact that they have a certain function. And however that function was acquired, it is no accident that the information is misleading. (p. 413)

According to Fallis's definition, disinformation need not be intentional in order to qualify as disinformation;

it must only have the function of being misleading. In the case of psychological projection, the person being misled is first and foremost the projecting person themselves, and potentially those witness to the projections. However, to some extent, it remains an open question— are Trump's projections essentially unconscious defensive reactions, or are they perhaps part of an intentional political strategy? Either way, Trump's projections function in a misleading manner that potentially benefits him politically—his systemic use of projections creates a veritable atmosphere of disinformation, which can contribute to a destabilized perception of any given situation. Significantly, the use of projection extends to individuals within Trump's inner orbit, such as the recent episode of Secretary of State Mike Pompeo criticizing NPR for being an example of the "unhinged" news media after having had a fit of rage halfway through an interview with the reporter Mary Louise Kelly (Wong, 2020).

It is worth noting that one of Trump's early professional role models, his lawyer and fixer, Roy Cohn, employed projection quite consciously as a political weapon. The paradigmatic example of this is Cohn's activities during the so-called Lavender Scare of the early 1950s, when Cohn, assisting senator Joseph McCarthy, outed scores of government employees for being gay, irrevocably tying homosexuality to Communist sympathizing, which ended their careers, even though Cohn was himself gay. Surely Cohn was well aware that his own disavowed sexuality projected onto his opponents could lead to the political results he was seeking. ▪

References

Cole, B. "Trump Calling Adam Schiff 'Deranged' Is a Projection of What the President Thinks of Himself, Says Psychiatrist," *Newsweek* (December 2019)

Fallis, D. "What is disinformation?" *Library Trends* (2015)

Goldberg, M. "The Nightmare Stage of Trump's Rule is Here," *New York Times* (January 6, 2020)

Kakutani, M. *The Death of Truth: Notes on Falsehood in the Age of Trump* (Tim Duggan Books, 2019)

Kernberg, O. F. "Projection and projective identification: Developmental and clinical aspects," *Journal of the American Psychoanalytic Association* (1987)

Meissner, W. W. "Projection and Projective Identification," *Projection, Identification, Projective Identification,* ed Sandler, J. (Karnac Books, 1988)

Wong, E. "Pompeo Denounces News Media, Undermining U.S. Message on Press Freedom," *New York Times* (January 25, 2020)

Jared Russell
jaredkrussell@hotmail.com

stu·pid·i·ty

In explicating the thought of Socrates, Nietzsche wrote that philosophy was an effort "to harm stupidity" (*The Gay Science*, §328). According to Nietzsche, humanism teaches us that it is our egotism that is to blame for our misery. Socrates taught the youth of Athens that it is our thoughtlessness that is to blame.

What if psychoanalysis were to take this thought seriously and propose stupidity as a valid concept? That is, what if, instead of using this word in a pejorative way as an insult, we were to conceive stupidity as a tendency inherent to the human mind? To tell a friend they are being stupid is to express concern for their well-being and to warn against continuing along a particular path of thought or action. To refer to a stranger or to people in general as stupid is a form of arrogance expressing contempt, which is itself a form of stupidity. What if there were other possibilities for this word—possibilities that would open up new avenues for critical thinking in the effort to resist tendencies toward collective self-destruction? Can we think of stupidity not as the absence of but as a structure of thought, and can we think it from a specifically psychoanalytic register as a previously unrecognized form of defense?

stupid (adj.): 1540s, "mentally slow, lacking ordinary activity of mind, dull, inane," from Middle French stupide (16c.) and directly from Latin stupidus "amazed, confounded; dull, foolish," literally "struck senseless," from stupere "be stunned, amazed, confounded," from PIE *stupe- "hit," from root *(s)teu- (1) "to push, stick, knock, beat" (www.etymonline.com)

As the etymology of the word indicates, stupidity is not ignorance; it describes a state into which we are thrown by being hit, stunned, "struck senseless"—a state of *stupefaction* that is a response to a certain violence. To be stupefied is to regress in the face of the unexpected, to have one's critical faculties paralyzed.

But the pejorative connotation is also relevant here: we become stupid in being stupefied when we fail to take responsibility for our stupefaction and instead blame it on the situation or agent of injury itself. Passively embracing our stupefaction in this way constitutes the failure that is our stupidity.

We can resist this failure with the help of an affect that all historical communities have, until recently, taken great care to cultivate within their members: shame. When I feel ashamed of my stupidity, I am already engaged in a struggle to overcome my stupidity.

The basis for the cultivation of shame is the child's identification with adults that links the generations and that constructs what Freud called the superego. To be truly stupid is to be unashamed of one's stupidity—to have relinquished the historical, intergenerational fight for intelligent, mature thought.

I am on holiday in a gorgeous location, and it is a beautiful day outside. I've gone to the trouble of bringing several books with me that I've been waiting months to have time for. Yet I am inside my hotel room with the curtains closed, playing sudoku on my smartphone. How many times has this happened before? A countless number of times—whenever I casually turn on the television instead of opening a book. Reading was something I spent a lot of time as a child not only doing but watching my parents do. Unconsciously drawing on these memories, I become aware that, in this moment, the smartphone is smarter than I am—I have lost a battle with this object in becoming captivated, struck senseless by this device with which I am in an ongoing war for my time and attention. Realizing how stupefied I have become, I feel ashamed, so I am motivated to go outside and read.

It is an ordinary moment, but it communicates to me something crucial: that it is shameful to be human because our stupidity is irreducible. Stupidity is not an error in judgment. It is not a defect of cognition. It is the capacity of the human intermittently to lose or to fail to live up to its humanity. To acknowledge this is not to accuse someone else of something I myself am above or of which I am incapable.

Just maybe, the dignity that the tradition of humanism ascribes to us is not something simply given. Perhaps that dignity must be fought for on a daily basis, and not just blindly defended as an unassailable moral ideal. A dignity that I merely have because I am born— due to no effort of my own—seems a less-than-dignified dignity. Perhaps we might recognize our humanity as a condition that must be sought after and won, rather than an equally distributed, banal commodity.

And perhaps psychoanalysis might be conceived on this basis: as a struggle against ordinary thought and behavior— an effort at self-overcoming.

It seems incomprehensible that climate change as a consequence of two centuries of global industrialization is still debatable, as if it were still debatable whether smoking causes lung cancer. But climate change remains a legitimately debatable issue because it belongs to a discourse that at least pretends to respect the socially essential category of fact. In contrast, an alarming number of Americans report that they believe in the existence of angels. Outspoken media figures profess that the earth is flat because their ordinary perception confirms this. With the winter holidays come protests against a media conspiracy that wages a war on Christmas. Fundamentalisms of all kinds promise eternity in reward for accepting that scripture is infallible.

Why would psychoanalysts fear acknowledging such attitudes as forms of wish-fulfilling fantasy, even valorizing some as instances of "faith"? In no way am I suggesting that to be a person of faith is to be stupid; rather that even when fantasy is morally protected, it is no more dignified than other forms of uncritical, immature thought. At the opening of her editorial to the previous issue of ROOM (10.19), Hattie Myers rightly laments the fact that "We have lost our grip on any shared sense of reality." But she goes on to invoke the boogeymen of "post-truth philosophers" and "deconstructivists" without asking whether it is our very commitment to unrestricted liberal tolerance that is to blame for this situation. Deeply empathic understanding may indeed be something that psychoanalysis and certain aspects of religion share, but that does not make it a viable political strategy for creating the radical systemic changes that have become absolutely urgent. As Hannah Arendt devoted her lifetime to articulating: politics is a domain of agonistic struggle, not mutual understanding. Under the looming threat of Donald Trump's reelection, it is more important than ever that we not confuse complicity with respectfulness.

A patient is rehearsing the impact that her childhood relationship with her mother has upon her current relationships. She is speaking of how the praise she receives at her job causes her overwhelming anxiety because in being "put on a pedestal," she risks being revealed as an utter disappointment. We have gone over this sequence many times, each time carefully articulating the link between her present experience and the distorted lens that her past imposes. When we can piece together recollection and affect to produce transformative insight, the tone in the patient's voice demonstrates a sense of empowerment that is the motor of the treatment.

However, this morning, the patient does something different. Upon discovering once again how her past distorts her experience of the present, this time she seems to deflate, and she says, "This is what I always do. I'm so stupid." That is, not only does she feel stupid, but feeling this way indicates to her just how stupid she is, unlike everyone else, which appears to justify the outburst of contempt for herself. "I guess I'm a piece of shit," she intones, with the implication that I couldn't possibly understand what it's like to feel this way.

When the shame of being human goes unacknowledged, people are left alone with this sentiment, which, as a result, metastasizes to a form of self-hatred. The sanctimonious valorization of immaturity only makes us feel more devastatingly alone in our judgments about ourselves.

There is nothing extraordinary about our biological birth. Reproduction is not a specifically human accomplishment. Accomplishment is what humanism originally intended to celebrate. The psychological birth of the human infant— to use Margaret Mahler's extraordinary turn of phrase— demonstrates the first steps in the overcoming of our fundamental helplessness and dependency. The child is not unintelligent but stupefied by a world that is exciting, chaotic, and complex. An adult is one who is not so stupefied by this complexity, one who is capable of internalizing the difference— which is not to say the opposition—between fantasy and reality.

Acknowledging our shortcomings and combating self-righteous moral outrage with a sense of humor might do a great deal more to bring us together than insisting on our essential dignity. Despite claims about our dignity, we can no longer ignore the fact that we are irresistibly prone to succumbing to experiences of stupefaction that the global marketplace is now organized around exploiting to the point of collapse. If psychoanalysis is to be politically relevant today, it is not as a means of insisting upon the value of each human soul, but as a Socratic form of resistance to the stupidity that we each individually and together collectively tend toward, as this is symbolized by the election of a shameless, illiterate game show host to the office of the presidency of the United States. ▪

Michael A. Diamond
diamond@missouri.edu

The Fissure

There is a psychic fissure in America's exceedingly fragile democratic body politic. In the face of political tribalism and an awakened and reinvigorated far-right white nationalist movement in America, civil servants (nonelected career public servants) from the Departments of State, Defense, NSC, and elsewhere have come forward to testify truth to congressional power, attesting to the impeachable actions of the Trump administration—actions that depict a criminal and amoral public enterprise. These nonpartisan officials are bearing witness and speaking truth to power, regardless of whether siloed Republican representatives of the House and their counterparts in the Senate are willing to hear the critical testimony of federal bureaucrats.

If the great American experiment of democracy, which requires two functioning and mutually respectful political parties, is to survive and, eventually, arise from its shattered deathbed, these knowledgeable and seriously dedicated, apolitical government employees—who, by testifying, put themselves at great risk—may be our last hope. In fact, it might be their testimony and their commitment to personal integrity and democracy that ultimately protect the rest of us from tyranny and authoritarianism. In fact, these courageous, nonpartisan, nonelected public servants may signify the remnants of collective confidence in these otherwise dreadful, if not cynical, political times.

From my academic and psychoanalytic lens, I have for some time imagined contemporary psychoanalytic theory as a democratic, personal, and political enterprise (theory and practice), one that is deeply antiauthoritarian, notwithstanding a few controlling and misplaced dictatorial practitioners now and then. Consider for a moment the key psychoanalytic concept of free association, which covers meaningful experience at multiple levels (intrapsychic, interpersonal, group, and institutional and political systems) and dimensions (conscious, preconscious, and unconscious) of analysis—where contrary to fascist and authoritarian political dictates, we are free to think, associate, disagree, and dream. Psychoanalytic theory would appear to be uniquely suited to shaping the work of repairing and replacing oppressive and repressive broken relational and political systems which are often emotionally twisted by paranoid-schizoid modes of experience at the group and political levels of action, as well as the interpersonal and intrapsychic.

The psychic infrastructure of democracy

A polarized body politic comprised of a weak and rapidly deteriorating center with uncompromising extremes, particularly on the fascistic right, is currently doing great harm to the integrity of American democracy— harm we may never fully recover from. As Melanie Klein taught, integrated whole object relations are produced by more reparative and depressive modes of experience. These psychosocial processes and transformations are necessary for democracy and its inherent value as part of analysis at the individual, interpersonal, and group levels. The politics of tolerance, liberation, and freedom of association, of resistance and democratic restoration, are rooted in psychoanalytic schools of thought, particularly as relational and contemporary theory and practice. As evidenced in current events by courageous whistleblowers, a psychologically healthy and audacious public service is rooted in principled social characters— personality structures consistent with the ethos of psychoanalysis, democratic processes, and reparative politics.

Reparative politics refers to the holding of tensions between opposing parties, producing a third intersubjective space where imaginative compromise and policymaking are plausible. In theory, this collective act of restitution might eventually lead to a third narrative and a renewed democratic center in which the legitimacy of political opposition returns to the American body politic.

Social contracts, the third space, and reparative democratic politics

Much like in society, in the therapeutic, consultative, and analytic relationship there is a social contract. There are some rules and assumptions along with the development of trusting and coparticipant relationships. I would say that at this point in history, the return to the in-between space of the third is possible once society and body politic return to the idea of sharing a common democratic social contract reinstating the rules of checks and balances, as well as the legitimacy of political opposition and what was previously a relatively functional two-party system. This stands in stark contrast to our presently dysfunctional, polarized, and authoritarian politics in which Trump and the far right reject these rules

and promote autocratic executive power and monarchy, where the president is above the law. Hence, we have lost the social contract of our democracy, and we have lost the psychological and political infrastructure required for compromise and policy-making. We have lost the crucial third space (of intersubjectivity) between conservatives, liberals, and moderates, Republicans and Democrats. We have lost norms critical to our withstanding collective regression to a Hobbesian state of nature that is "nasty, brutish, and short." We have lost the essence of Freud's axiom "where id was ego shall be." One might say contemporary American politics are presently devoid of a systemic ego.

Psychoanalysis, political and self-deceptions

Psychoanalysis, and the application of critical psychoanalytic thinking to the vicissitudes of American politics, demands we pay attention to deceptions and fictional narratives promoted by the far-right-wing media and by Russian intelligence services. Promotion of these twisted narratives stems from paranoid-schizoid modes of experience fostered by an aggrieved and militant nationalist far-right movement. Delusional storylines are deeply destructive to our democratic society. We (protesters, citizens, voters, the press, university professors and the academy, and career civil servants at state and intelligence agencies) must neutralize these projections and take apart these dangerous conspiracies with reality-based counter-messaging. As citizens of American democracy, we must follow the lead of these courageous public servants who have already come forward and stood up against tyranny. This must be part of the strategy of the resistance against Trump and his destructive administration.

Here I am reminded of Harry Stack Sullivan's (1954) notion of "counter-projections," where the analyst attempts to neutralize projections in the countertransference. Possibly, this idea is consistent with what John Fiscalini (2004) calls "coparticipant psychoanalysis." From a theoretical perspective, I view this action-orientation as consistent with contemporary relational and post-Kleinian (object relational) theories and practices and the notion of making productive use of the countertransference.

Nevertheless, it's a bit more complicated when analyzing and theorizing politics.

Here I am referring to a *counterstrategy,* if you will, against the Trump administration and far-right conspiratorial media. The Trump public relations strategy—if we want to give it the dignity of calling it that—is more simply an unconscious, automatic, impulsive, and reactionary propaganda machine, where projections are targeted onto the Democratic opposition and their leadership. These projections are typically comprisedof blaming, scapegoating, and juvenile name-calling. Democratic leadership, journalists, and mainstream media must counter the lies and deceptions by *neutralizing projections and taking apart conspiracies* by consistently mapping the origins and sources of these falsehoods.

By "neutralizing" I mean finding a way to help that section of the population recognize the danger. One way is through the testimony of bipartisan public servants and whistleblowers. In other words, there needs to be a more concerted effort of counter-messaging on behalf of the resistance and democratic opposition to clarify and correct the false and hostile messaging of the far right.

Trump and his followers are incompetent and reckless when it comes to foreign and domestic policy and administration; however, they are effective propagandists with their political base and the Republican Party. We must call out their deceptions and distortions of the truth by countering the projections and fictional narratives. ▪

FELA'S STORY
Memoir of a Displaced Family

Phyllis Beren

Told through the lens of a gifted psychoanalyst,
Phyllis Beren writes as a keen observer
and as an engaged participant about her childhood
in a displaced persons camp after World War II.
Fela's Story: Memoir of a Displaced Family
crosses decades and borders from Poland to Russia,
and from Germany to America. This is a book about
resilience and the capacity to survive and to heal.
It is about memories lost and retrieved.
In our dangerous political climate Dr. Beren's story
is both timely and timeless.

AVAILABLE AT **IPBOOKS.NET**

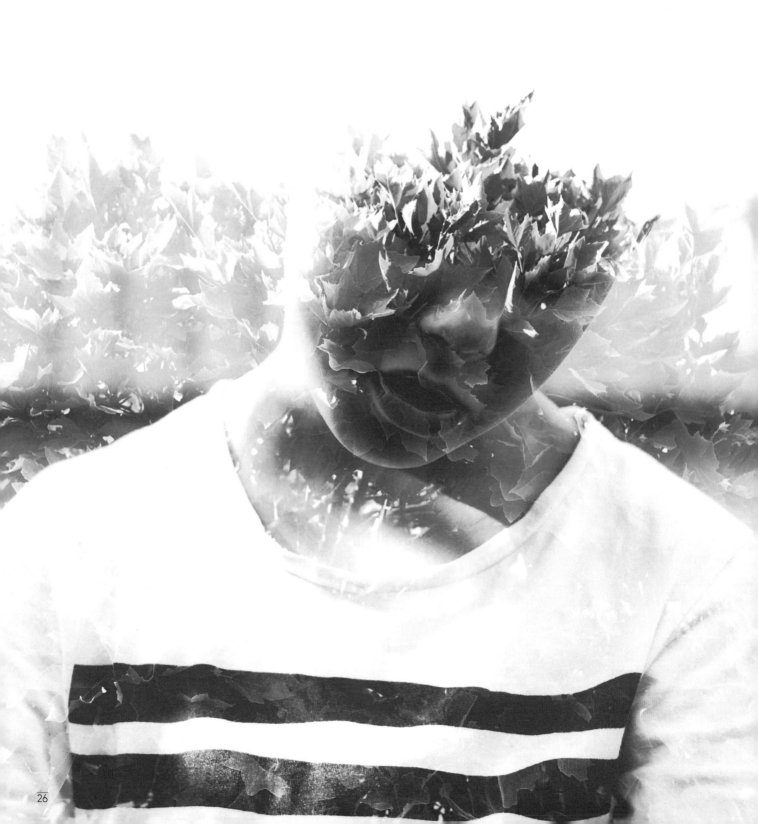

Zak Mucha
zak@zakmucha.com

Reassembling Fragments

When I was a little kid, I thought my uncle was hysterical. He told no jokes, but he didn't treat me like a kid, either. He was always a problem for the rest of the family. At one point, my mother told me, "If people in suits come looking for your uncle, you don't know where he lives." Actually, he lived down the block. My uncle always had a job but never seemed to be working. He would sometimes store things—twenty Weber grills, freezers full of meat— in my dad's garage. The back seat of his Trans Am was piled with clothes.

At family events, my uncle would wait until he had my attention and say, "You know this is all bullshit, right?" Hearing this was a relief, but I didn't know why. Sometimes he would ask me, very seriously, "So, how you like being a little kid?" To this day, I don't know if he knew the impossible layers to answering this question. I hated being a kid, and he would never acknowledge the joke or the truth upholding the joke.

Poet Charles Simic revels in his jokes and disruptions as they ground us and mark our place in the world. In one two-line poem, "The Voice at 3:00 a.m.," Simic summarizes this split: "Who put the canned laughter / In my crucifixion scene?" The poem's title, for me at least, hints at the despair Saint John of the Cross ascribed to those early morning hours. To superimpose sitcom laugh tracks onto the scene at Calvary, Simic lets the joke expand past the text, into the title, other poems, prayers, and every joke Simic has heard.

This dark humor is a trauma response, acknowledging the impossible questions with which we are left. This is the absurd truth hinted at with a rim shot to take the anxiety edge off the unknown, reminding me of the Christian mystic Richard Rohr quoting a Talmudic scholar: "God is not nice. God is not an uncle. God is an earthquake." Which mirrors Michael Eigen's summary of Bion's unknowable reality: "We cannot count on the niceness of O." Simic is able to be joyful about the horror of O.

Analytic work demands we incorporate the uncertainty of the world, the unknowable, into our existence. The horrific what-ifs, what-nexts, and shoulds and the dread

Photo by Markus Spiske

of how do they see me exist, marking the unbearable anxieties left wordlessly outside of our narratives while driving our behavior.

One poem of Simic's plays with the horrible possibilities floating within a self split by trauma:

I was stolen by the gypsies. My parents stole me right back.
Then the gypsies stole me again. This went on for some time.
One minute I was in the caravan suckling the dark teat
of my new mother, the next I sat at the long dining room table
eating my breakfast with a silver spoon.

It was the first day of spring. One of my fathers was singing
in the bathtub; the other one was painting a live sparrow
the colors of a tropical bird.

As a child in Belgrade, Simic survived the German bombing and Nazi occupation. His childhood became a series of disruptions as he and his family crossed boundaries delineated by violence, ethnicity, culture, and language. The trauma of multiple displacements exists in his blurred boundaries between consciousness and dreams, and in the links which discern a magical realism from a gray reality. Simic accepts each paradox as true: "A poem is a place where affinities are discovered. Poetry is a way of thinking through affinities."

Simic finds the affinities between the sacred and the profane, a process described by Donald Kalsched in repairing the self divided by acute or accumulated trauma. This split creates internal roles be they the protector/persecutor of Kalsched's trickster, Winnicott's true and false selves, or Fairburn's internalized bad object. All of this is a response to the impact of the unbearable, the "primitive agonies" of the infant that cannot be told directly precisely because of the displacement of affect from memory and language.

The juxtaposition of the uncanny and the absurd with the safe and familiar runs through the body of his work. Simic began learning the joy of studying philosophy and poetry while living in a Times Square hotel with his unemployed father, waiting for the rest of their family to join them in a new world. Understanding where one does not fit in, one can more clearly see the place in which one stands. And Simic says, "The poem is an attempt at self-recovery, self-recognition, self-remembering, the marvel of being again… A poem is a piece of the unutterable whole."

One patient of mine survived a career where each job site was potentially fatal due to the physical job requirements as well as the homophobic aggression of coworkers that, not coincidentally, mirrored those of the family from which he escaped. He entered sessions with his jaw clenched shut, his core muscles tightened against impact, walking on tiptoes, and ready for the potential assault that came with many interactions. He saw no metaphors in the world; all uncertainty was concretely deadly.

I began considering therapy's possible conclusion when he opened one session with "It's all a joke, isn't it? It's real and serious, and it can kill me, but it's not so serious, is it?" He struggled to explain a tiny moment during the previous week when the world seemed to be covered with a sort of intangible overlay, like a scrim that both obscured and illuminated everything. He asked, "Am I nuts? It's like I'm in a movie, but it's real. But I don't really care. It feels okay."

This numinous experience might have been what Michael Eigen summarized as Bion's unknowable reality: "We are part of one great paradoxical monism, a wholeness that thrives on fragmentary processes, bits and pieces throbbing with significance."

In therapy, we find those places where we do not have words. Simic wrote, "[The poem] measures the gap between words and what they presume to name…the gap between being and being-said."

Several years ago, I ran a team at a community mental health agency. We worked with individuals suffering severe psychosis, substance abuse issues, homelessness, incarcerations, frequent hospitalizations—cases marked "too intensive" for other programs. On call 24/7, most of the work was done in our cars or in hotels, hospitals, or courtrooms. Our team had to be able to walk in these spaces that were blurred by the boundaries of psychosis.

One client would only acknowledge the therapeutic relationship if he was Steven Seagal and I was Bruce Willis. Some days, we were cop partners running around the city; some days, he was the psychiatrist and I was his lawyer. These creations made the world tolerable, but the world hardly tolerated his psychosis. Evicted from a flophouse hotel for his disruptive behavior, I took him to another. We cycled through a lot of housing. "You do the talking,"

he said as we walked in. "I got your back." As I already knew
a bunch of people in the hotel, many greeted me.

My partner whisper-scolded, "We're CIA covert ops.
You think you should be talking to all them?"
"If I don't, they're gonna get suspicious, right?"
"That's right."

Most often, I couldn't tell if he was letting me in on the joke
or not, but I had to always be willing to enter that gap between
words and the world.

Simic's book *Dime-Store Alchemy* provides a narration for the work
of Joseph Cornell, an artist who never left his childhood home
in Astoria, Queens. In his basement studio, Cornell made
shadow boxes and collages from found objects. He took
discarded bits and bobs found on his searches through
Manhattan bookstores and junk shops, creating tableaus of paper
birds and soap bubbles, giving titles to his internal narratives
of old hotels and lost children. When he couldn't find
appropriate containers for his found items, he built his own
boxes, so they seemed a natural container for the collections
inside. Works would sit unfinished for months and years until
he found the right objects to place together for reasons
he could not intellectualize.

Simic described Cornell's method and motivation:

You don't make art; you find it. You accept everything
as its material…

The collage technique, that art of reassembling
fragments of preexisting images in such a way
as to form a new image… Found objects,
chance creations, ready-mades… abolish the separation
between art and life. The commonplace is miraculous
if rightly seen, if recognized.

Each piece of art or work of prose can be seen as the demand
for an empathetic witness standing to one side, understanding
some but not all, sharing a portion of space with the fragmented
individual attempting to put words to the impossible.
The artist or poet seeks a witness to acknowledge
that they also see, and can laugh at, the unknowable.

This is to complete the link of communication any art demands.

Which is what I think my uncle did.

Which is what I think we are supposed to do. ▪

Iris Fodor

ief1@nyu.edu

When I was a child in the Bronx
in the 1940s, whenever a plan
for the future was proposed,
it would be followed by the phrase
"after the war."

My parents would say, **"after the war,"**
my father would quit Ritz radio
and start his own business.

My mother would say, **"after the war,"**
we will move into a house in Queens.

I would meet my long-absent
grandparents who returned to Russia;
I longed to meet them *after the war*.

My aunt who slept in my bed
while her sailor husband was away
said she would have a baby *after the war*.

After the war, we would give up
our ration cards; we could have meat every
night for dinner, not have to roll up balls
of silver for the war effort,
not have to hide under our desks
in school when the sirens sounded.

After the war, the neighborhood bullies
will stop beating the Jewish kids
and the Italians and the Jews could be
friends again.

After the war the summer of '45,
I was ten.

We had a big block party on Garden Street
in the Bronx.

The street was closed;
there was spotlights, streamers,
tables full of food. There was a band,
and we all swing danced
in the street. The Italians and Jews
celebrated together.

After the war, the men in our apartment
building came back from the Europe
and the Pacific.
My uncle brought back grass skirts
from the Marshall Islands,
and large pear-shaped speckled
shells, which I still have.

But my aunt did not get pregnant.

After the war, the Cold War began,
and my grandparents could not come back
from Russia. After the war,
the letters we got from them were full
of holes, like cutouts.

After the war, we could not travel
to Russia to see them.

After the war, my mother said
we could not tell anyone about
our grandparents in Russia. **After the war,**

Earlier draft
Published in newsletter
of Peace in Our Times

Earlier draft Published in newsletter of Peace in Our Times
Volume 3 Number 4 | Fall 2017

the McCarthy committee came
to my city college campus hunting
for communists. I learned to keep
my mouth shut.

After the war, some Jewish kids
on my block were still being beaten.

After the war, in school, we still hid
under our desks; now we feared the bomb.

After the war, deep underground shelters
were prepared in buildings, subways.
Russia was the new enemy.

After the war, my father
did not change jobs. Instead,
he learned to fix TVs.

After the war, we had the first TV
on the block, a small, square black-
and-white box.

We saw the images of survivors
from the liberation from the camps,
the bombed-out cities of Europe.

Never again.

But **after the war**, Cambodia, Bosnia,
Rwanda happened.

After the war, the UN was built.
Our high school class visited the first glass
building on the East River.
We were told that now nations
could meet, get along to make peace.

After the war, the Berlin Wall
was built.

After the war, I grew up, left the Bronx.

I lived in London and the ruins
of the Blitz were still there.

After the war, there was the Vietnam War.
In Boston, my house was the headquarters
for the draft resisters. I joined the antiwar
faculty and marched with thousands
to the Pentagon.

After the war on 9/11, I watched
from my window in Lower
Manhattan as a plane crashed
into the Twin Towers.

Then, we invaded Afghanistan,
and Bush rained down
"shock and awe" on Iraq.

Missiles fly again as Trump brings
us to the edge of war with Iran.

After the war, Columbine, Sandy Hook,
and Parkland happened.
Now my grandchildren learn
to hide in classroom cupboards
to flee school shooters. ∎

William W. Harris
billywh@me.com

And Then It was Over

And then it was over. yes, he was finally impeached.
>>> No, despite his claims to the contrary,
he was not exonerated.
>>> So the question is just what is his status at this point
in United States history?
>>> After binge watching news channels, for months
we have finally completed watching the impeachment
>>> trial.
>>> The house managers did a commendable job
of Presenting the case against president Trump.
>>> The Republican managers' defense was somewhere
between histrionic, Embarrassing, and ineffective.
>>> Nevertheless, leader McConnell still rules
with an iron hand.
>>> The question remains, Will it make any difference?
>>> Assuming for the moment that it does not,
and that Trump continues as president
- at least until the election,
>>> what are those of us who are exhausted, dejected,
demoralized, and depressed to do?
>>> Even if/when he is finally gone, he will leave residual
images, feelings, of anger, depression in all of us
in his wake.
>>> How will we cope with these internal,
recurring images? Can we recover? How long will it take?
>>> It feels like we have been living in an earthquake
and we are left anxiously awaiting the aftershocks
which we know
>>> will come but we don't know when and how severe
they will be. My fantasy is that we
>>> could turn our bodies and Our minds inside out and take
a thorough "acid Bath" to rid ourselves of any leftover
>>> Trump images, sounds and feelings.
>>> How is it possible for us to erase completely
the images of the children in cages at the border?
How is it possible
>>> to watch the president and his many manifestations
spouting total climate change denial?
>>> Will we ever be able to expunge Rudy Giuliani
and his two indicted sidekicks from our consciousness?
>>> What will be or should be the therapeutic response
to dealing with these Trumpian aftershocks?
>>> For a family these aftershocks Will also exist within
spouses and children's minds and bodies. How will parents
deal
>>> with their children's new nightmares?
How will the children deal with their parents' nightmares?
>>> Even with a new president (hopefully), these images
and feelings will last. Addressing them in the therapeutic
session will become a
>>> new challenge both for training and treatment.
>> For those of us who have been "binge watching" t v,
what's next? Will we be able to adjust to life without
Nicole, Chuck, Ari,
>> Chris, Chris, Rachel, and Brian?
Will we be able to just go to a movie again?

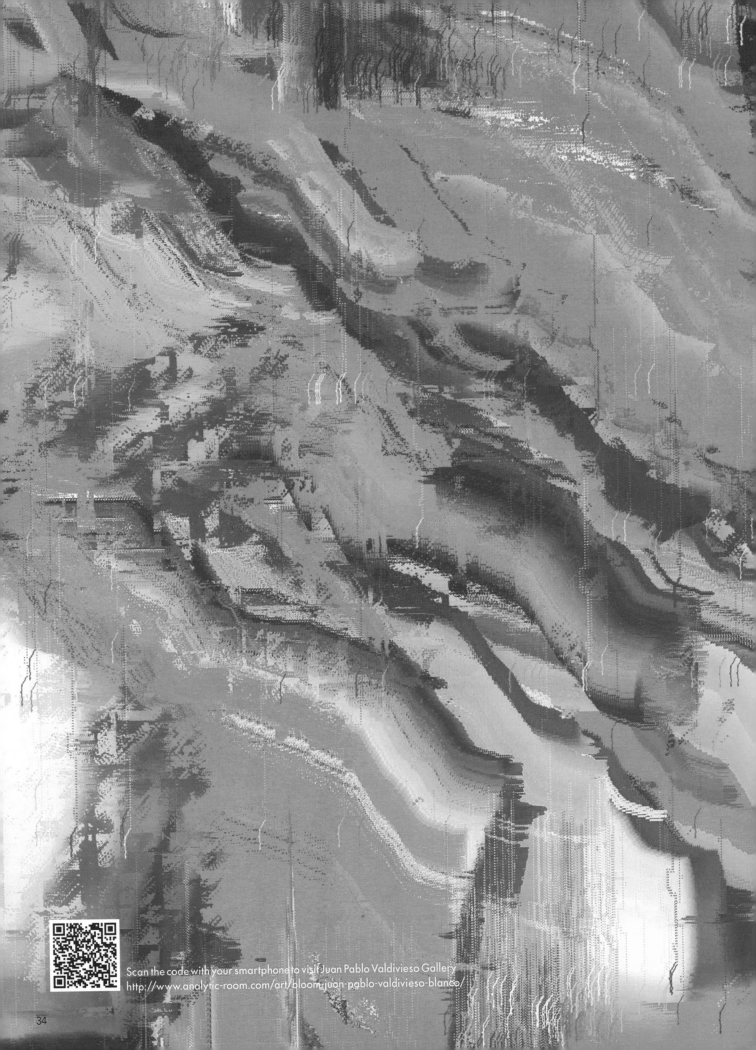

Scan the code with your smartphone to visit Juan Pablo Valdivieso Gallery
http://www.analytic-room.com/art/bloom-juan-pablo-valdivieso-blanco/

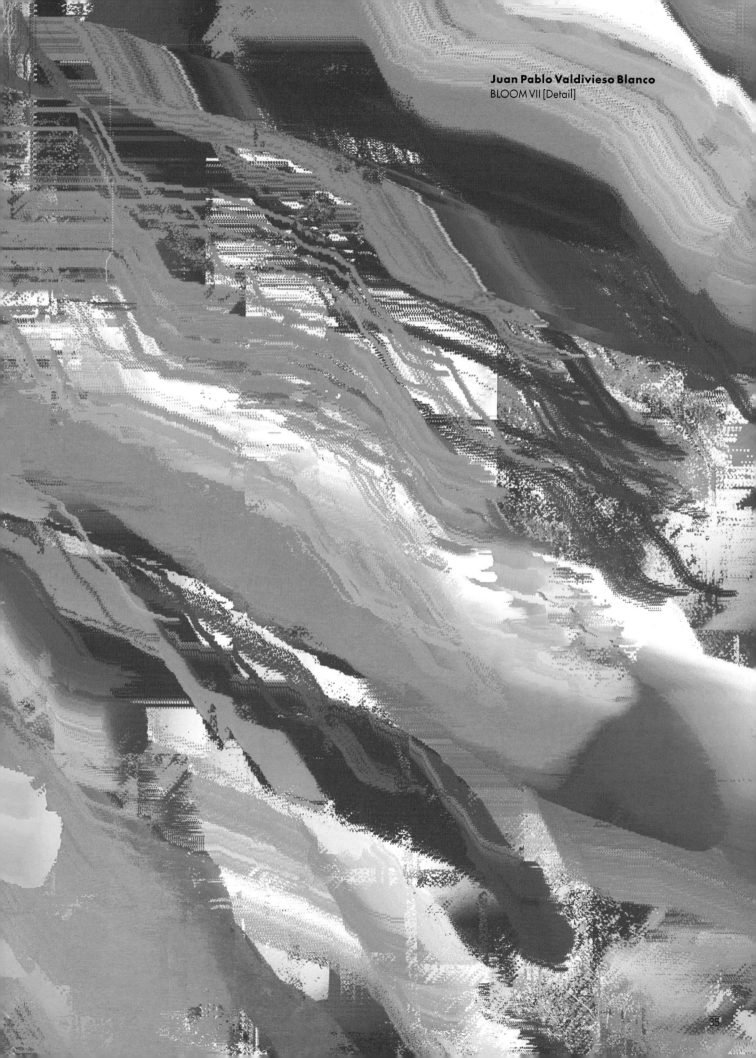

Juan Pablo Valdivieso Blanco
BLOOM VII [Detail]

Today, we may be facing
that same crisis, a different kind
of sudden death.
I feel both too old, at thirty-four,
and not old enough
to see history repeat itself.

WAR AND GRIEF

Michael McAndrew
mcandrew.mr@gmail.com

Grief can be a strange thing, particularly when it is associated with mourning. Psychoanalysis in some sense was born out of grief. Freud first mentioned the death of his own father, a powerful figure, in *The Interpretation of Dreams.* The death of Jacob Freud in 1896 prompted Freud, as a result of his own self-analysis of the matter, to write *Die Traumdeutung* in 1899. A significant portion of Freud's self-analysis was addressed in letters to his colleague Dr. Wilhelm Fliess, such as the following:

> The old man's death has affected me deeply.
> I valued him highly, understood him very well,
> and with his peculiar mixture of deep wisdom
> and fantastic light-heartedness he had a significant
> effect on my life…in my inner self the whole past
> has been awakened by this event. I now feel quite
> uprooted. (Freud 1986, 202)

Freud would later refer to the death of Jacob as vital in his own self-analysis: "It was a portion of my own self-analysis, my reaction to my father's death— that is to say, to the most important event, the most poignant loss of a man's life" (Freud 2010, xxvi). This, the death of a loved one, is something I've found to be true, both in my own analysis, and have observed in my own clinic: a clinic of grief and mourning.

My own Lacanian analysis began shortly after the sudden death of my father, and I think that analysis perhaps couldn't have begun without it, as his death began to uproot me in the many identifications I had held on to, a process psychoanalysis would hasten. It is no small irony that I work as a grief counselor, working primarily with parents who have suddenly or unexpectedly lost their children, the other side of what brought me into psychoanalysis. And I remember how proud my father was that I served in the navy, but I wasn't able to say what I say now when he was alive.

As I write this, I think of another kind of grief knotted into the other aspects of my life that of my own reminisces on my service in the US Navy. From 2009 to 2013, I served aboard a nuclear-powered aircraft carrier as a member of the Aircraft Launch and Recovery Equipment division, one of many charged with the launch and recovery of fixed-wing and rotary-wing aircraft on the US's most forward deployed carrier. It was during this time that the United States reentered a state of belligerence with the Islamic Republic of Iran.

In 2012, the Iranian government warned the United States not to send another carrier through the Straits of Hormuz, threatening to close the only outlet to and from the Persian Gulf between Iran and the United Arab Emirates, a place of great strategic importance to the United States. The US threatened to respond if such an event were to occur. No such response was necessary, thankfully, but it was a tense time in the Straits of Hormuz, and I surely wasn't the only sailor in the American or Iranian navy who was relieved a crisis was averted.

Today, we may be facing that same crisis, a different kind of sudden death. I feel both too old, at thirty-four, and not old enough to see history repeat itself. My own reminiscences remind me of another event of brinksmanship when cooler heads prevailed: the Cuban Missile Crisis. The response of Chairman Nikita Khrushchev to President John F. Kennedy (another navy man):

> We and you ought not now to pull on the ends of the rope
> in which you have tied the knot of war, because the more
> the two of us pull, the tighter that knot will be tied.
> And a moment may come when that knot will be tied
> so tight that even he who tied it will not have
> the strength to untie it, and then it will be necessary to cut
> that knot, and what that would mean is not for me
> to explain to you, because you yourself understand perfectly
> of what terrible forces our countries dispose.

In *Civilization, War and Death,* Freud wrote, "Every man has a right over his own life and war destroys lives that were full of promise; it forces the individual into situations that shame his manhood, obliging him to murder fellow men against his will." Cooler heads prevailed then and spared the lives of millions of people. Like Freud, I don't pray, but I wish for peace, and the hope that cooler heads prevail now, as they did then. And I grieve. I grieve my father, I grieve the boy that I was, and I remember the face of my enemy and wish him well in his life and hope it is a long and peaceful one. ▪

Afterward

Photo by Mael Renault

Ofra Bloch
ofrabloch@gmail.com

There was no way I could have known when I went to Germany to interview the descendants of perpetrators of the Holocaust for my film *Afterward* that this journey would take the form of a personal analysis. On the surface, I wanted to rid myself of my hatred for these Germans, who had done nothing wrong but whose ancestors tried to kill my people. I wanted to stop the cycle of hate and othering before I passed it on to my own sons, to the next generation.

When I was in my first year of psychoanalytic training, a patient once told me, "Enough with the Holocaust."
I felt he was denying not only my reality but also my identity. His words affected my capacity to attune and respond optimally to him at that moment. I wanted him to face my uncle, who spent four years in Majdanek concentration camp and lost his wife and two children. I wanted him to stand face-to-face with my husband, who lost his childhood on the run from the Nazis, along with his entire extended family. I wanted to shake him, to scream in his face that the Holocaust is a daily event in my home and in my life, and that I have no choice in the matter. I ended up not sharing my subjectivity with him. Instead, I wrote about him in my final paper that focused on those four words:
"Enough With the Holocaust."

After all, the Holocaust has been an event that has kept on being created anew. Just the other day, when I inno-cently pointed out to my husband, who is a Holocaust survivor, that there were twin cherries at the bottom of the bowl, he responded, "Like Mengele's twins."
In my reality, the word "twins" can never be an innocent one. Neither can the word "train," for that matter.

In 2013, I was sitting across from Ingo, the former neo-Nazi leader of Berlin, listening to him share horrendous stories of his past. When I asked him about his experience talking to me, an Israeli Jew, he replied that he was not thinking in those categories anymore. At that moment, I felt as if the floor fell from underneath my feet. Without really understanding the stormy emotions that were boiling inside of me, I asked for a break. I left the interview room and started weeping when I had some privacy. I was flooded all of a sudden with a fear of annihilation.

The very same person who could have hated me at one time for being Jewish, who had been capable of hurting me, was erasing my identity again in making that statement, which he intended to sound conciliatory, as proof that he had changed his ways. When we resumed the interview, we were able to be open and discuss the experience in a meaningful way.

I wanted to interview the German "others" and focus the camera on them. I wasn't supposed to be seen in the final version of the film and even intended to edit out my questions and let the German interviewees speak without interruption. Unbeknownst to me, *Afterward*'s cinematographer, sensing the emotional storm brewing, asked the second cameraman to direct his camera at me.

I am an unschooled filmmaker who forgoes working from a script. When I returned from the shoot in Germany, I realized two things: first, the film had no arc and no ending; and second, once I looked at the footage of me onscreen, it became evident that the boundaries between me as a subject and me as a director had vanished.

It was then that the fog lifted and I realized the missing piece: I had to talk to Palestinians, the other group of "others" whom I was raised to fear and hate, supposedly because they were keen on my destruction and would orchestrate the next Holocaust, which was just around the corner.

In 2016, I went to Israel and the Occupied Territories to inter-view Palestinians in order to hear about their experiences under the Occupation. I wanted to understand the impact of one historical event, the Holocaust—which has provided an identity-making narrative for Israel—on another historical event, the Nakba, and on the present-day reality of Palestinians. I wanted to demonstrate that listening to Palestinian narratives does not diminish or belittle the magnitude of the Holocaust. I often wondered why so many people feel threatened when the suffering of another group of people is mentioned, as if someone is trying to enter an exclusive club that has a sign: "For Jews Only." Are our hearts not large enough to feel the suffering of others?

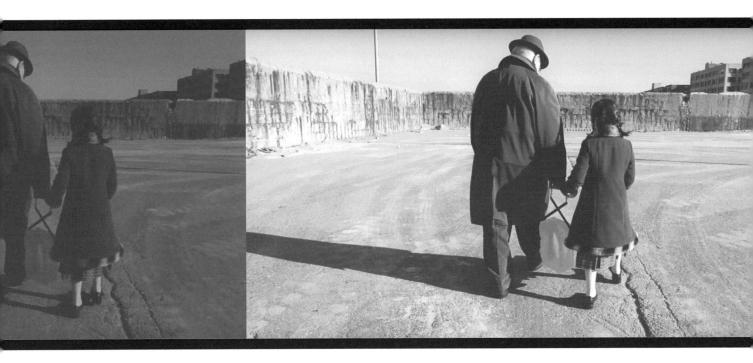

When I interviewed Germans, I could indulge in the clear binary that existed between us. They represented the victimizers, and I represented the victim. While I had to listen to them through my own fear and anger, through my sorrow and pain, I was not in the hot seat of the accused. But interviewing the Palestinians brought challenges that had to do with my own identity and moral compass. It forced me to face my own guilt over what is being done in my name to another group of victims.

When I was walking through the Old City of Jerusalem, where a few people were stabbed the previous week, I was filled with fear. Though I deeply resented the massive presence of armed soldiers, I also felt grateful for their protection. By the same token, when I walked along the walls surrounding a refugee camp, which were decorated with images of Palestinians who fought against the Occupation, I could understand the despair that had led them to choose violence as a form of resistance. And yet, as I looked into their eyes, all I could do was scream inside, *You've killed my people.*

But then I was listening to Basel, a young Palestinian photographer, who documented the 2014 Gaza War, telling me that he can't imagine Israel's Prime Minister Netanyahu eating breakfast with his kids, because he holds him responsible for the killing of four Palestinian children who were playing soccer on a beach during the war.

Or I was looking into Bassam's eyes, when I stood on the playground constructed by a joint Israeli-Palestinian organization, Combatants for Peace, in memory of his ten-year-old daughter, Abir, who was killed by an Israeli soldier. It was then that I clearly realized that evil can be unearthed in all of us under certain conditions, regardless of our religious or ethnic background, and that we all have the capacity to become bystanders who stop asking questions and remain silent in the face of moral collapse.

It can be difficult at times to listen to the "other," those who view reality through different lenses, and it was no different when I encountered Germans and Palestinians. While I didn't chase away my emotional reactions to what I heard because I believed they were an important element of the nonverbal exchange, I was mainly focused on providing the film's subjects with a safe environment to share their truth with me. I was not there to evaluate, compare, debate, or judge their feelings. I hoped that by being listened to, they would feel acknowledged and recognized, and a real dialogue might begin.

Back in New York, as editing began, I realized the similarity between the skill sets of a psychoanalyst and a filmmaker. While the video camera and the psychoanalyst's ears and eyes capture the content of the session/film, the editing stands for the analytic skills that are used in order to give meaning to what was captured. The psychoanalyst interprets dream images that reflect the working of the patient's unconscious,

WATCH IT NOW!

#Afterward
For EST/VOD @AfterwardFilm
is now available on
@AppleTV and On Demand.
https://geni.us/Afterward
Website: afterwardthefilm.com

and the filmmaker/editor uses her own unconscious to make connections between various images.

Talking to Germans allowed me to evacuate some space in my mind that was filled to capacity with my obsession with the Holocaust. Perhaps I wanted all along to make a film about the Palestinians, but my path led me first to encounter Germans, so I could learn from their experience dealing with feelings of guilt and responsibility.

The most basic concept of psychoanalysis is that the sources of our motivations are unconscious and therefore hidden from us. I was no exception. I was unaware that I was making a film about myself and my own journey of discovery and change. In an early scene in *Afterward*, I walk with my great-uncle Binyamin, together carrying a dripping ice block. Each drop exposes the lies and half-truths told to me as a child. In the last scene of *Afterward*, I look out the window of my childhood home expecting to see the almond tree across the street that used to blossom just in time for my birthday. The tree is gone, and I tear up. It was only after the film was completed that I could comprehend that I was shedding tears for the innocent time when I could believe that I belonged with the right and the just. ∎

Reading Racism Deeply

If the usual formula is that the negative affects hide in positive speech, overtly racist discourse flips the polarity, but the possibility that a racist discourse might hide a forbidden love, sexuality, or attachment is all too often ignored in clinical treatments that have been published.

Daniel Rosengart
daniel@rosengart.com

One way to mark the progress of psychoanalysis as a discipline is to watch the increasing sophistication and subtlety with which it reads into the discourses of its patients. When psychoanalysis departs from its earliest roots of "chimney-sweeping" catharsis (Freud, 1893), it marks its new method by finding hidden meaning in the speech of the patients, hidden especially to the speaker, and its method of cure was the communication of that hidden meaning. Freud's famous and infamous letter to Fliess (1897), in which he announces the abandonment of the seduction hypothesis, whatever its disastrous political ramifications, is a statement of purpose and radical new method: insofar as we hear psychoanalytically, we hear through and beneath the manifest meaning of the text.

What Freud discovered beneath the manifest was often simply its opposite. The hysteric is unmasked as a sexual adventurer, the obsessional neurotic is revealed to be full of jealousy and hatred, and so on— if not a reversal, then a displacement or a transference, feelings meant for one put onto another. The manifest holds a simple relation to the implicit, one that could be gleaned from the patient, despite their objections, with relative ease.

It was not long before both the methods for seeking the latent meaning and the array of possible meanings became more sophisticated and further removed from that manifest (it can even be seen in Freud's later work). If Freud was one of the "masters of suspicion" (Ricoeur, 1965), his successors opened the door to a world in which the suspicion had to be of both the patient and the listener, as well as the culture from which each spoke. Gone are the days of certain and definite interpretations, and, by and large, it is never assumed that a bit of manifest content, a symptom or a belief or a feeling, has a single and knowable meaning. This complexity not only respects the fundamental unknowability of the unconscious (which Freud knew theoretically, but was not always able to hold clinically), but it also allows psychoanalysis to enter into new cultural and clinical contexts, leaving behind its largely monocultural roots.

Except that there are relative blind spots, where the complexity of contemporary analytic theory gets collapsed into something more certain, where our negative capability (Bion, 1970) fails us and we fall back into the old formulas of "this means that" and fail, clinically and to some extent theoretically, to interact with the complex discourse in front of us. One of the most significant of those areas, in particular

in the realm of clinical case formulation, is the use of racism and the psychology of racists.

Too often the racist's racism is taken at face value, with the usual analytic curiosity foreclosed upon in favor a pre-knowing about the sources and true meaning of the racism. Well trained to hear the rage, envy, and resentment in discourses of love, psychoanalysis has too often accepted that the rage and contempt toward the racial other hides nothing more than the identical feelings inside the racist. If the usual formula is that the negative affects hide in positive speech, overtly racist discourse flips the polarity, but the possibility that a racist discourse might hide a forbidden love, sexuality, or attachment is all too often ignored in clinical treatments that have been published.

Instead, there is the standardized analytic origin myth of the racist in which the patient suffers from unprocessed intrapsychic material—in the form of repressed desires like envy (Bird, 1957), incest (Kurth, 1947), lust and fear of feces (Kovel, 1970), or anxieties, as in Young-Bruehl's (1998) structural taxonomy of oral, anal, and Oedipal prejudices. Or, in more recent analytic accounts (e.g., Suchet, 2004; Guralnik, 2011), the unprocessed is intergenerational trauma and enigmatic inherited histories, handed down from parent to child without ever becoming verbalizable. These accounts add something incredibly valuable—they look at the analyst's racism as well as the patient's. However, some of the fundamentals remain similar and reflect the simplest use of psychoanalytic metatheory: the bad is held, without language, inside the self and then projected into the other as a form of relief from suffering. Even in the case of intergenerational trauma, where the racism is treated less as a pathogenic defense mechanism and more as an unwelcome genetic inheritance, the function of the racist utterance or thought is treated as stemming from internal suffering and the meaning of it is to be found in the symbolization of that suffering.

Along with the origin myth, there are the clinical discussions of treatments of racists, which also follow prescribed paths. They share a common focus—the racist— and a common perspective on racism—that it consists of "the feelings of hatred, disgust, repulsion, and other negative emotions" (Dalal 2006, p. 132, though he is also critical of this definition) that the individual feels for a group. Generally ignored are the communities and rituals that surround and construct overt racism and, particularly,

the larger discourse on race that surrounds the hatred and dismissal of the racialized other. This simplified model, which looks in many ways like the frame of both prewar psychoanalysis and the popular medical model exemplified by the DSM, turns away, one assumes in disgust, from racist discourses and assumes they contain nothing more than their manifest content. The search for latent meaning ends with the predictable equation: racist hatred = some other hatred, displaced.

But racism exists as part of social ideologies that, like any other ideology, are largely unconscious and socially repressed. Our psychoanalytic model of racism puts it as the repressed in a world in which racist ideology is unacceptable. This is the racism held by the mortified few in a manifestly antiracist society, the kind that is spoken about in therapists' offices, that is feared, that is either ego-dystonic or else at least clearly part of a personality disorder.

But in the world we live in today, there are other sorts of racism and other racist discourses our patients participate in. In the present moment, the internet has birthed (or normalized) varieties of racist communities that hide under layers of irony and parody of leftist discourse: the pick-up artists, men's rights activists, the intellectual dark web, evolutionary psychology, Trump, and all the non-affiliated posters of "anti-PC," pro-Trump, anti-multiculturalism detritus. Far from the solitary bastions of hatred we hear about in the case studies, these racist discourses form in private societies, with their own dialects of memes and symbols, and their own rules of what can and cannot be said. They can be hiding places for more than just hate, all the more because they are discourses in which hate need not be repressed at all. Quite the contrary: in these communities, what must be hidden is love, connection, desire (particularly homosexual desire) —these feelings and thoughts are what threaten the fabric of the community; hate is the glue that keeps it together (e.g., Bollas, 1984; Symington, 1980—though they write about connective hate in terms of the individual, not the group). If we read racist discourses as having no more potential than as hiding places for hate, we impoverish the racist's unconscious and forget the fact that a symptom is fundamentally an act of creativity in a mad world.

Just as the new age spiritualist finds in their ideology of universal love a perfect hiding spot for hatred and contempt, so the racist may find in their community

and their discourse a home for other repressed affects. Racist communities are in many ways ideal homes for those who fear their own love or the effect their love might have if it became conscious. Love can explode the psyche just as much as hate, and for those who have to repress their love but can never bear to destroy it, a discourse in which love is repressed and held privately safe can feel like a lifeline. I am trying to describe those people who feel their love to be contaminating, too mixed with hatred, or else so powerful it would destroy the loved one, or too incestuous, or too homosexual, or else some other configuration among many possibilities in which so-called positive affects (though not felt to be so) must be kept hidden away. To miss these possibilities, to hold the racist to their word and remain incurious about the complexities of their outer as well as inner world, is in these cases to find ourselves colluding with their need to hide the good, to fall into their world of confusion. When we find ourselves thus confused, we can unwittingly recreate the same environment of disconnection and lovelessness that helped necessitate the racism in the first place. This is not only a therapeutic risk, but, as we have seen in the rise of global far-right racism, a political one as well. ∎

References

Bird, B. "A Consideration of the Etiology of Prejudice," *Journal of the American Psychoanalytic Association* (1957)

Bollas, C. "Loving Hate," *Annals of Psychoanalysis* (1984)

Dalal, F. "Racism: Processes of Detachment, Dehumanization, and Hatred," *Psychoanalytic Quarterly* (2006)

Freud, S. "The Psychotherapy of Hysteria from Studies on Hysteria," *The Standard Edition of the Complete Psychological Works of Sigmund Freud, Vol. II* (1893)

Freud, S. "Letter 692 Extracts from the Fliess Papers," *The Standard Edition of the Complete Psychological Works of Sigmund Freud, Vol. I* (1897)

Kovel, J. *White Racism, A Psychohistory* (Pantheon Books, 1970)

Kurth, G. M. "The Jew and Adolf Hitler," *Psychoanalytic Quarterly* (1947)

Guralnik, O. "Ede: Race, the Law, and I," *Studies in Gender and Sexuality* (2011)

Suchet, M. "A Relational Encounter with Race," *Psychoanalytic Dialogues* (2004)

Symington, N. "The Response Aroused by the Psychopath," *International Review of Psycho-Analysis* (1980)

Young-Bruehl, E. *The Anatomy of Prejudices* (Harvard University Press, 1998)

Aneta Stojnić
aneta.s7@gmail.com

Arnold Richards:
A Spirit of Activism

In the lead-up to our anniversary issue,
I've had the pleasure of talking to Arnold Richards.
A recipient of the 2000 Mary S. Sigourney Award
and the 2013 Hans W. Loewald Memorial Award,
Dr. Richards is a leading figure in the democratization
of psychoanalysis and in bringing psychoanalysis
to the world at large.

You were one of the early supporters of ROOM
and one of the people who recognized its significance
and relevance for the analytic community
from the very beginning. What was it that caught
your attention?

Initially, I noticed and appreciated the graphics.
I am very much into graphics. One of the first things
I did when I became the editor of the *Journal of the American
Psychoanalytic Association (JAPA)* in 1994 was to redesign
the cover and the graphics of the journal. All the editors
after me have kept the same design. I am very proud of that.

But ROOM is an important creation. I've always felt
that there should be a place in psychoanalysis for a discussion
about things that are going on in the larger world. A typical
peer-reviewed journal with scientific quotes and papers
doesn't offer that. This sort of venue is vital for the field
and needs to be nurtured and maintained.

There aren't that many platforms for psychoanalysts
to comment on other issues, "nonprofessional issues,"
that are of great concern for them and are important
for the profession and the larger world. That is why I think
ROOM is so important. In it, the whole political approach

is important. To go beyond the field—
whether it has to do with art or literature or politics—
is everything that makes us interesting as people.
I wonder why no one thought of it earlier? (laughs)
Although I must say I had some thought about doing
something like that and this has resulted in my starting
the new journal *The International Journal of Controversial
Discussions,* which will include commentaries
and discussions about broader issues and topics
from different standpoints—things that wouldn't go
into a psychoanalytic peer-reviewed journal.

This brings us to another topic that you are already touching
upon: How do you see the role of psychoanalysis
and psychoanalysts in contemporary society?

I don't think psychoanalysts should be offering diagnostic
opinions about public figures, Trump or whomever.
I do not think that is appropriate. You can diagnose someone
in your office. I have a big problem with discussing Trump
using analytic terms like *narcissistic personality disorder*
and with all that's written about public figures along those lines.
To me, a psychoanalyst should talk as an informed citizen,
as someone who knows something about human nature,
rather than someone who knows mostly about human

psychopathology. We can offer our opinions about evil, rather than make assertions in terms of psychopathology, psychosis, and the like, when it comes to world affairs.

How can psychoanalysis as a field contribute to the social context that we live in? I came to psychoanalysis from the field of art, where in the mid-twentieth century there was a big debate: Why are we in a white cube? Why don't we connect to the world? How can we become more activist and political? Such a shift in thinking about the role of art in the world had a significant impact in the history of contemporary art. I have a feeling that something similar is happening in psychoanalysis at the moment.

Psychoanalysis is part of our zeitgeist. It is in our culture at large. Psychoanalytic ideas are part of modern and contemporary art, history, and literature. What Freud offered, and what analysts since Freud have offered, has some relevance to many, many different fields. That's true for psychoanalysis broadly defined.

And how do you see the role of activism in all this? Is it appropriate for a psychoanalyst to be an activist as well?

I have just been talking about psychoanalysis, not psycho-analysts. If you ask about psychoanalysts, I would rather talk about all mental health professionals. I would lump us all together. If you live and offer yourself as someone who is trying to help people, that's who you are. Psychoanalysis as a treatment is just one modality that we use in mental health.

I don't think there is anything specific about mental health professionals as citizens that would keep us from doing anything we might do as activists. I marched in Washington; Arlene (Kramer Richards) was in a Martin Luther King Jr. march when we were in the South, in Petersburg, Virginia. We were at the first Fifth Avenue Vietnam Peace Parade, at the very beginning of the protests. During the civil rights movement, when I was in Petersburg, Virginia, I belonged to the Southern Christian Leadership Conference. I met Abernathy; I treated patients from Virginia Union University, which was a black college. So I was very much involved there, and I have certainly been an activist.

I think all psychoanalysts perhaps have a special obligation to become activists for causes that affect the lives of their patients. There is no way of treating a person

separate from the fact that they can't have health care or if they are in an environment that is going to kill them. So you can't really isolate what you do in the office from what you do in the world. That doesn't mean that people who are not psychoanalysts don't do as much, or more, as citizens. But I would like to believe that psychoanalysts are especially concerned about civil rights, human rights, and so forth.

Do you think that institutes can also have some role in connecting the field of psychoanalysis with wider social and political issues? Nowadays, psychoanalysis and psychoanalysts are more and more interested in issues of race, gender, cultural diversity, inclusivity, and so on. How do you think that institutes or analysts can respond to those interests?

I think that for institutes and analysts those sorts of interests should be high up on their agenda. It certainly makes life more interesting and makes people feel more engaged and ultimately more fulfilled if they can have impact in different fields. As an analyst, you sit in your office, you see how many patients you can see, and for some people, that's enough. But that depends on the personality of the analyst. For someone like Vamik Volkan, that's not enough. Not everyone has that psychological propensity to be engaged in the world and want to make a difference.

Do you think that a more interdisciplinary approach is important for the relevance of the field today?

It's very important to be part of a larger world, the political world, the therapeutic world, the research world. That is very important.

You have also been teaching in China for many years. Could you say something about that experience?

I can say a lot. In fact, that's one of the most important things that my wife, Arlene, and I have done. It's one of our most important contributions to psychoanalysis. And I think this is where the future is. We first went to China in 1978. The trip was sponsored by the American Psychoanalytic Association. Of course, China was very different then than it is now. We returned eight years ago; Arlene was invited to go to Wuhan, where they have a psychotherapy hospital built by the government. People in charge of China were very concerned about the high rate of suicide

of their children, and Arlene was invited to help them understand the problem. So she said, "Okay, I'll go, but you have to invite also my husband." (Laughs) And they said, "Okay, send his CV." So she sent my CV, and they said, "Fine, he can come too." So we both went. We spent a week at the Wuhan psychotherapy hospital. We each gave lectures to the staff, and I ran a group therapy session on a closed ward. I am not a group therapist, but it was a very interesting experience. At the last session, they let me know how grateful they were and said they would like to sing a song for me. Each of them sang, and there was some rivalry, but then they told me that they wanted me to sing them a song. (Laughs) So I sang "In an Anarchist's Garrote." Do you know that song? I think it's a West Virginia anarchist song. And after that, we sang "The International" together.

At the beginning, one of the things that I used to connect with people in China was telling them that my father was a Bolshevik in Trotsky's army. Even though he deserted the army (laughs), that gave me a certain amount of cachet as having been part of the Russian revolution before Stalin.

After that visit to Wuhan, we started a China-based psychoanalytic psychotherapy program. We had three courses, and in each year, we had 220 students. We are now about to start the last year of our third course. Arlene and I have been very involved in getting people to participate. Dr. Tong runs the program brilliantly and is now a training analyst in the IPA.

Between visits, I teach online. My last course must have had between four hundred and five hundred students once a week. I also gave an online lecture, which was a kind of supervision session. I was told there were thirty-eight thousand attendees on the internet for that session. I mention the numbers to indicate the scope of interest in psychoanalysis in China. They are hungry for it. It's been an important experience, and I think that we've had a major impact. They even built another hospital. The important thing is that this is all supported by the highest levels of the Communist Party, because they are concerned about their own children—that is my sense.

This sounds fascinating: psychoanalysis as some kind of a government project. Why psychoanalysis? Why do you think they chose to go with psychoanalysis as the treatment?

When we first went to China in 1978 and they learned it was it was the American Psychoanalytic Association, they put us in the best hotel in Beijing because they somehow felt that psychoanalysis was important. When I want to a case conference, they wanted to know what the latest in JAPA was. The Chinese were interested in what was in, and for them, somehow, either the concept or the word *psychoanalysis* was in. Of course, there is also interest in CBT, and other people push that, but psychoanalysis still has a certain amount of prestige because it's a word that describes a climate of opinion, really, for the mental health professionals. Of course, people ask: Why does the government allow this? My own sense is that maybe, just maybe, the government feels that it's better to protest in the office than to protest in the streets. We don't know... but the fact is, so far, it's being supported. Yet recently, the platform we used for online teaching was banned by the government because it was encrypted and couldn't be listened to. So this is an issue, and we really don't know for how long this can continue.

In 1978, it was very interesting that they saw the community was very much part of the treatment of the patient. On the other hand, they said, "We treat our patients with heart-to-heart talk and Haldol." This was a ward for severely disturbed patients, so they would give antipsychotics. But the term for psychotherapy is "heart-to-heart talk." Think about it. Doesn't that say a lot? So they recognized the value of interpersonal emotional exchange. ▪

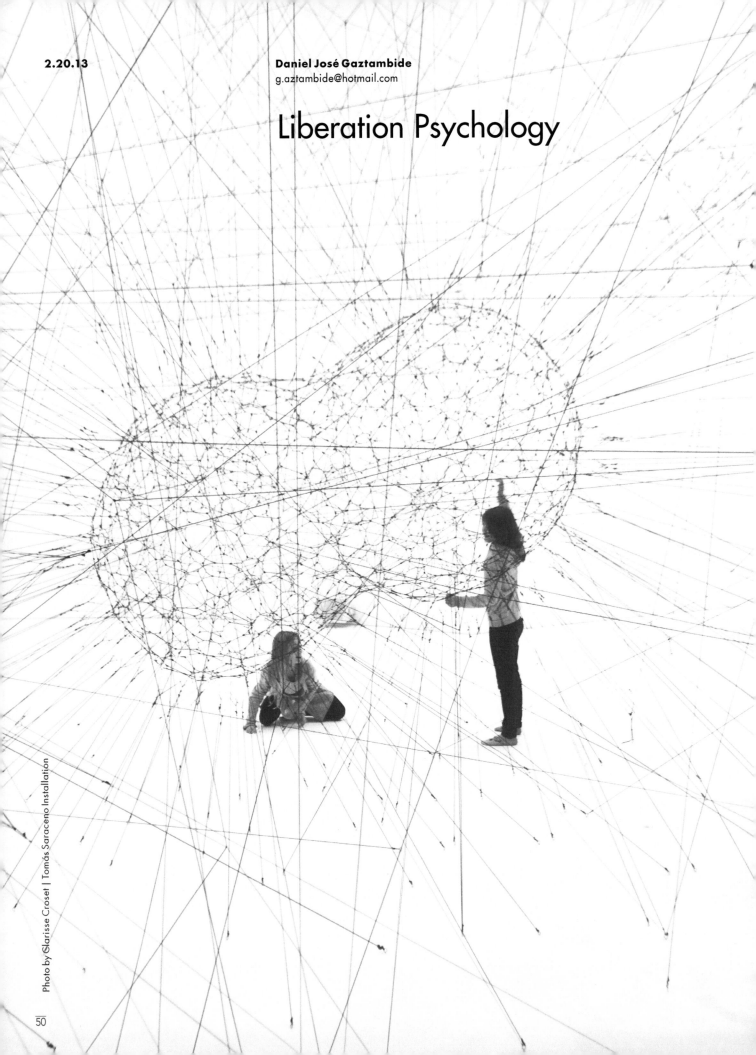

Daniel José Gaztambide
g.aztambide@hotmail.com

Liberation Psychology

"¿Viste?" my mother asked.
"Tú eres un melancólico-colérico."

An old-world phrase from an old-world book
of personality types. *You see?* my mother said.
You are a choleric-melancholic type.
Cholerics, she explained, tended toward extroversion
and were very goal-oriented. Melancholics, by contrast,
tended to be analytical, deep thinkers yet intuitive.
The kind of people that "tuned in" to feelings.

"Tiene que ver con cómo entendemos al otro,
como un psicoanálisis."

*It has to do with how we understand the other,
like a psychoanalysis.*

Psychoanalysis—the word hung in my mind like a revelation.
People could tune in to one another, literally *the other*
("al otro"), like a frequency. And when we're on the same
frequency, understanding can happen.

And just like that, on a patio resting under the shadow
of a great mango tree, psychoanalysis was born in Puerto Rico.
At least, as far as my eight-year-old mind was concerned.

"¿Pero y si estás desafinao?" I asked my mother.
But what if you're out of tune?

She laughed. "¡Esa te la debo!"

I owe you that one, she answered. Turned out,
I'd have to go into psychology to figure that out.

Other kids wanted to be astronauts, firemen, doctors,
president of Puerto Rico (kids dreamed), president
of the United States (kids didn't dream big enough).
I wanted to be a psychoanalyst.

This was only reinforced as I grew older.
My mother wished she could have studied to become
a psychological profiler but didn't have the time, education,
or resources, and she encouraged and supported
me in my interests and later studies. She told me about Freud
and how people who learn psychoanalysis conduct psychothera-
pyand help people. My closest association to what helping
people looked like growing up was my childhood church
in Puerto Rico, where my mother was also a secretary.

It was through my church that I learned about a God of healing;
a God of the downtrodden, the widows, the poor,the orphans,
and the strangers; unconditional love for the oppressed—
ideas and impressions that would later concretize with my
exposure to liberation theology and liberation psychology,
a method for tuning in to and understanding other people
deeply. It was also a simple proposition that would
come alive in my later clinical work.

Liberation theology and liberation psychology both made
sense in my mind. A subtle link began to form, a connection.

My undergraduate studies at Rutgers University in New
Brunswick, New Jersey, were enlightening regarding the state
of psychoanalysis today, and the message was clear—Freud
was dead, a Western European, bourgeois, positivist, racist,
classist, sexist, homophobic fossil best left to—as Edward
Said once remarked with concern—"the dustbin of the history
of ideas." At best, perhaps contemporary relational
psychoanalysis was salvageable. In fact, it might prove to be
a progressive alternative to Freud and Freudian psychoana-
lysis, with its emphasis on race, class, gender, and sexuality
in context, culture, and society. But thinking back to Said's
own attempt to recover Freud, is that all there is?

Later on, I found myself at Union Theological Seminary
completing a master's degree, going back and forth between
classes with the founder of Black liberation theology,
James H. Cone, and pioneering psychoanalyst Ann B. Ulanov.
Liberation theology and its various forms—Black theology,
Latin American liberation theology, queer theology; feminist,
womanist, mujerista theologies—is a movement that draws
its inspiration from Marxist, feminist, anti-racist, queer,
and postcolonial thought in its assertion that God makes
a preferential option for the poor and oppressed. Liberation
psychology, developed by the Jesuit priest Ignacio
Martín-Baró, represented an extension of this social justice
framework into psychology itself. From Martín-Baró's point
of view, psychology itself needed to be reconfigured
"from below" and take a stand against oppression and injustice.

Central to his thinking was the need to conduct a "recovery
of historical memory," an excavation of those histories,
relationships, and traditions that sustain liberation.
Not a call back to an idealized past, but a recovery
of those resources that support struggles for social justice.

Here, in my exposure to liberation theology and liberation
psychology in the works of Cone along with Gustavo
Gutierrez, Ignacio Martín-Baró, Paulo Freire, and Frantz
Fanon, a greater and bigger rupture tore open between
the God of the Oppressed and the Freud, Klein,
and Winnicott of the Unconscious.

Was psychoanalysis only concerned with the psyche
and not society? Was liberation theology and psychology
only concerned with society, and not the psyche?
Was there a history that needed to be recovered that, in fact,
showed a concern for both?

In witnessing this gap, a word jumped out in my reading
of Paulo Freire and relational psychoanalyst Jessica
Benjamin's texts—*intersubjectivity,* a process taking place

From Freud to Liberation Psychology

A PEOPLE'S HISTORY OF PSYCHOANALYSIS

DANIEL JOSÉ GAZTAMBIDE

Daniel José Gaztambide's *A People's History of Psychoanalysis* is available on Amazon.com and on the Lexington Books website.

A discount code is available on the author's website https://drgpsychotherapy.com/

between subjects, one wrestling with the other in order to create and find a sense of mutuality, a third space where one another's humanity can be held. A connection is made, recognition birthing a third space that sustains self and other in dialogue and reflection.

But the third always ruptures. The ground tears open, and the third collapses into the twosome falling into discord. And out of this collapse, the world can be healed anew if we can but survive the tumult that ensues. The smoke clears, and I discover the other as well as myself. Like the sun that shines and the grass that grows after a hurricane.

Intersubjectivity, and the similarities in its use in liberation psychology and relational psychoanalysis, suggested a bridge to link together incommensurate worlds. It was the first sign that these seemingly incompatible and disparate discourses were, in fact, not so disparate. Was there such a thing as a preferential option for the *repressed?* I had started from the possibility of integrating liberation

psychology and psychoanalysis—the God of justice and the *psicoanálisis* of my youth. But the truth, it turned out, was that this was akin to asking how you would integrate a tree and its branch. One should instead ask how the branch broke and fell from the tree to begin with.

Fast-forward to starting my doctoral program in clinical psychology at Rutgers University. Questions and questionable assertions abounded from peers, colleagues, and supervisors:

You're interested in psychoanalysis?
But you're Puerto Rican!

Psychoanalysis is pretty white. How can a theory with such a racist history have anything to offer to social justice?

The thing about people of color you have to understand is that they are not really "psychologically minded."
They don't do insight and reflection. Cognitive-behavioral therapy is a better fit for them.

Well! What to do? Apparently, it had been decided that psychoanalysis was not a good fit as a treatment or training option for people of color, as they, Puerto Ricans among them, were seen as lacking certain cognitive capacities. Furthermore, psychoanalysis was at best ignorant and at worst antithetic to questions of social justice. How is it that both more conservative white psychoanalysts and progressive, multicultural psychologists of color could share these views?

But what if it was all wrong, or at the very least woefully incomplete? What if, in its inception, psychoanalysis was developed by a historically oppressed people that were persecuted as non-white? What if this same group of people identified as leftists seeking social change, ranged from social democrats to Marxists, socialists, and communists? What if they developed a system for not only understanding people, but also for understanding society, and how race and class are used to maintain inequality by rupturing our ability to understand one another? What if this system was then drawn upon by women and men committed to social justice—from Harlem Renaissance thinkers to Latin American psychiatrists and educators to anti-fascist resistance fighters to Afro-Caribbean revolutionaries? What if psychoanalysis actually developed a set of ideas that gave birth to liberation psychology itself? What if liberation psychology was *rooted* in psychoanalysis? What if, in fact, psychoanalysis belonged to all of us who are colonized and oppressed? ▪

POETRY
from the manuscript
Slow Fuse of the Possible:
On Poetry & Psychoanalysis

Kate Daniels
kate.daniels@vanderbilt.edu

ROOM 2.20 | A Sketchbook for Analytic Action

In many ways, that is really all we were: two women alone
together, by choice, for many months, and then for many
years, in a quiet room. At times, one or the other talked. At
times, one or the other listened. At other times, there was
nothing but silence.

Scan the code with your smartphone to visit Juan Pablo Valdivieso Gallery
http://www.analytic-room.com/art/bloom-juan-pablo-valdivieso-blanco/

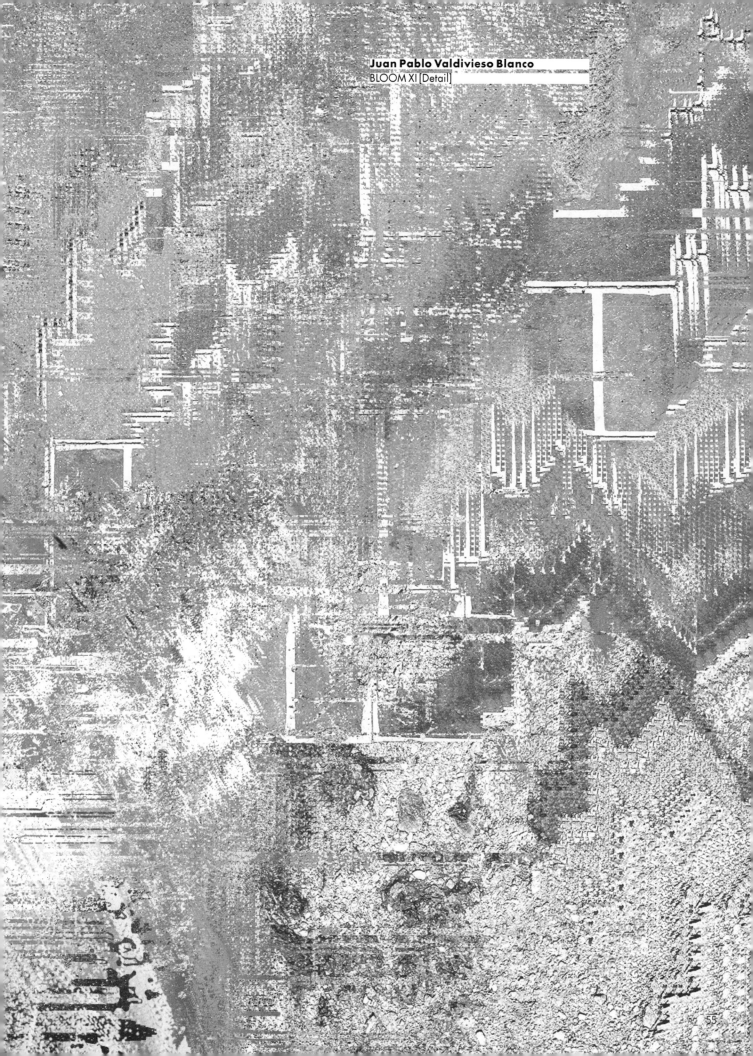

Juan Pablo Valdivieso Blanco
BLOOM XI [Detail]

Fiction
liz.mckamy@gmail.com

For Crying Out Loud

—Elizabeth Herman McKamy—

He was sprawled and cornered against his nightstand and tethered to the mattress by a tangle of bedclothes. Sleep anchored him, making it hard to stop his arms from thrashing. Blood and fire gagged his throat, blocking the scream. Panicked children. Mothers, naked, keening.

Sergeant screaming, "For chrissake, Bendix, *shoot!*"

His heart drummed against his chest. Salty sweat burned his eyes. Like a man buried alive, Tom Bendix clawed his way into the day ahead. Why? Why in god's name had he told her about the gun? Two years, ups and downs for sure, but now he'd really blown it. No way to maneuver out of this one.

"Nope," he lied when she asked if he ever brought the gun to therapy. "Just sleep with it. Under the pillow. Have every night since I got back. No big deal, Doc," he told her.

She'll fire questions at me today, Bendix thought as he kicked the nightstand back into place and yanked covers off his bed. *What the hell made me blurt that out? Damn crybaby is what I am. Got Dr. Rose all in a knot. Pissed off pretty good too probably to boot.*

"God damn it all!" he railed into the dark.

The clock's face flicked 4:08. Dream broken, nerves jarred into focus, he noted his surroundings: chest of drawers by the window, tan sofa pale in the early morning light, shirt and trousers pressed perfectly, hanging on the closet door. From where he stood, he could see his paired white washer and dryer in the alcove by the kitchen.

Perched on the bed's edge, Bendix straightened his bulk and tried Dr. Rose's relaxation exercise. Breathe deep. Release. Breathe. Release. Face squeezed tight, silently Bendix repeated her words in his mind: *Inhale deep. Release. Inhale deep. Release.* The clock face flicked: 4:22. He began again. *Inhale deep. Release. Inhale. Just three or four minutes is fine,* he could hear the encouragement in her words. He stopped at 5:07. *Good enough is good,* he knew she'd say.

By 7:15, Bendix had cycled his bedding twice through washer and dryer, rotated his mattress, made and remade his bed, corners squared. After showering, he fixed breakfast: three eggs, yolks unbroken, over easy. Three slices of toast. Three tablespoons grape jam. Lots of sugar-laced coffee.

His med setup took hours, and Bendix routinely filled his pill boxes on therapy days, after breakfast, before lunch. So many bottles of them. So many to keep straight. VA always changing things around. Crappy pill cutter nicking off bits of Seroquel. He had to start over again and again. Blunt fingers always struggling to place Depakote just so beneath the razor-sharp blade. Position, set, slice. Position, set, slice. Collect the crumbs.

His thoughts bounced back to Dr. Rose, then veered to his ex, the bitch, and Lois, too big and important nowadays to call.

And dead in the ground, Ma Bendix, crazy as a snake, her *shut up*s and *crybaby*s yammering in his ear.

"To hell with the lot of them," Bendix said, then got the Colt .45 from where he left it on the pillow.

Back in the kitchen, he grabbed a microfiber rag and can of solvent from the cabinet under the sink. Cleaning the Colt brought calm, its soothing focus familiar, predictable. He worked on the polish until it was time to shower again, eat a sandwich, dress for therapy.

Meanwhile, Alice Rose was edgy. She drew precise lines, then little boxes along her notepad's margins; she was restive, barely attentive as her two-o'clock patient's hour approached its end.

When he departed, Dr. Rose toyed with a floral arrangement perched on the spindle-leg side table by the door: lilacs, pink roses, baby's breath. She moved a few lilacs forward, then back again. Baby's breath buds scattered to the floor.

"What a mess!" she said, keenly aware of each elongated second as she picked up the bits.

Returning to her desk, she pulled apart paper clip after paper clip with the vague intention of linking them together. Why hadn't she gotten a consult on Bendix? Why did she push him about the gun? At the end of his session, for goodness sake! Couldn't she have left well enough alone? So he sleeps with the thing under his pillow. Why go and ask if he brings it to therapy? Fragile trust and comfort painstakingly established now so terribly disarrayed.

Too late for today. Inhale deep. Release. Inhale.

The waiting room buzzer announced Tom Bendix's arrival. Relief he chose to come to his regular session raced against Alice Rose's ratcheting anxiety.

"Enough," she said out loud and pivoted, out of habit, to survey her consulting room. Throw pillows in place. Papers stacked on the desk. Books aligned in the glass-fronted hutch along the wall.

Soothed, Dr. Rose stood, checked the fall of her sweater's hemline. She shifted the drape of her scarf until its fringed ends aligned just so. At the table by the door, she moved one lilac forward again, quickly brushed a fallen petal under the doily at the bouquet's base.

Moments later, Bendix entered the room, regarded her briefly, then approached his usual seat at the far end of the cream-colored sofa. As Dr. Rose took her place on the leatherette armchair opposite the couch, she watched Bendix retrace his steps to the doorway, remove a revolver from its cover under his overcoat, pause, then, with precision, set the Colt .45 on the spindle-leg table, resting against the vase of flowers. ▪

OPEN CALL

FOR SUBMISSIONS

Essays* | Poems | Fiction | Art | Photographs

We welcome clinical, theoretical, political, and philosophical essays, as well as poetry, stories, artwork, photography, and announcements.

*Length: Max 1500 words

NOW VIA SUBMITTABLE

analytic-room.submittable.com

ROOM is made possible through hours of volunteer time and your tax-deductible donations. Please consider helping **ROOM** by DONATING HERE:

Scan this code with your camera or visit the link below

http://www.analytic-room.com/donations

or send a check made out to:
IPTAR (in care of Room)
at IPTAR 1651 3rd Ave — Suite 205
New York, NY 10128

ROOM ISSUE 2.20
NEW YORK, USA

SCAN to download past issues

JOIN US!

We are pleased to invite you to

ROOM
ROUNDTABLE

We hear from authors
who interpret both
recent events and the larger
picture of our fractured world.

Join our mailing list visiting:
analytic-room/subscribe

Facilitated by Richard Grose
and Janet Fisher

SCAN to join our MAILING LIST

ROOM: A Sketchbook for Analytic *Action* promotes
the dialogue between contributors and readers.
ROOM's first issue was conceived in the immediate
wake of the 2016 US election to be an agent
of community-building and transformation.
Positioned at the interface between the public
and private spheres, ROOM sheds new light
on the effect political reality has on our inner world
and the effect psychic reality has on our politics.

CPSIA information can be obtained
at www.ICGtesting.com
Printed in the USA
LVRC030459080121
676039LV00009BA/43

9 780578 797205